ISBN 978-1-333-03164-0
PIBN 10455789

BWS

Pauli

VENICE

BY
GUSTAV PAULI

TRANSLATED BY
P. G. KONODY

1904

LONDON, W. C. NEW YORK
H. GREVEL & CO. CHARLES SCRIBNER'S SONS

LEIPZIG, E. A. SEEMANN

PRINTED BY ERNST HEDRICH NACHF., G. M. B. H., LEIPZIG

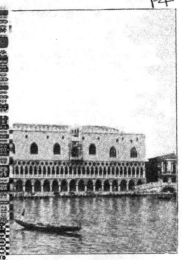

(...brary, Campanile and Doges' Palace)
...fall of the Campanile.

...tifiable to draw conclusions upon
...e same applies to the dwelling of
...particularly to an Italian town. At
...oured by the developement of the
...wn into centres of culture in the
...hty, self-centred individuals, each
...uliarities of customs and language.
...acter as Venice, for here antiquity
...later centuries; here there have
...ere of home policy, not to speak
...nure of her life this town, which
...rowing into a state, was, on the
...unexampled continuity these inter-
...since her position made Venice
...st by the Adriatic swamps, she
...a naval power could become
...es and far into modern times no

I

er the Venetians. This made it possible,
the town from its foundation to its fall.
example, where the influence of politics
and art would be as clearly perceptible

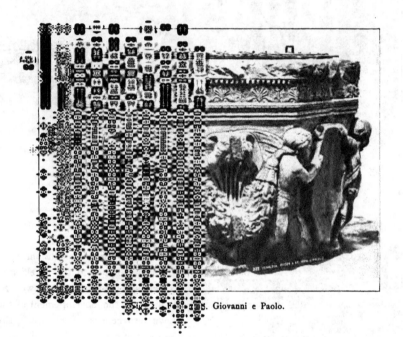

. Giovanni e Paolo.

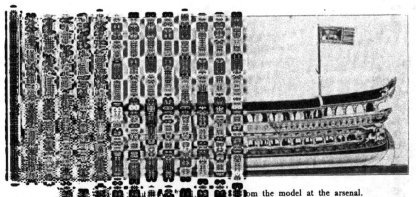

HE
...RK

HISTORY.

the small islands fringing the coast
Po were inhabited by a sparse
During the period of the migra-
flux of citizens of good position
from the fury of the Hunns, and
oths and Longobardi. Whilst the
nt and the old Italian population
invaders, the old and new Italian
of the marshy islands to form a
he sixth century the islanders were
and industrious and prosperous
the best source, from Cassiodorus,
e islands, each of which had at
the rule of its tribunes, became
the end of the seventh century a
re, as the islanders called him in
prince resided at Heraclea; later,
at Malamocco, and finally, after
ed, of the islands, on Rivo Alto.
s of the present Venice. A few
bridges with the new capital and
ng government palace was raised,

1*

...had brought from Alexandria in Egypt
...had received her supreme consecration
...es. The town now had a patron saint
...ones have possessed miraculous powers,
...diaeval christianity. The views of the
...Mark with the cause of the Republic,
...The banner of the Republic was that
...ded at the same time the apostle.

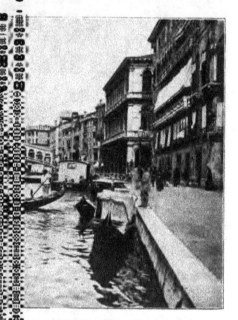

...4. ... with the Rialto Bridge.

...urable, not only physically, but at least
...ontier, between Byzantium and Italy, be-
...Venetians were the chosen mediators
...t. They have indeed played this part
...heir commerce and political power. Their
...been taken very strictly; soon a Greek
...mained of it, a title which was last used
...the twelfth century. The only sense, in
...assable understanding with the Eastern

Empire, was, that they secured freedom of trade and intercourse within its vast boundaries. They knew how to obtain the same rights from the Italian Empire of the German emperors, and when the second millenium dawned, Venice was already considered a flourishing commercial state, richer than all her neighbours. The Doge Pietro Orseolo II., the fried of the young German Emperor Otho III., established factories and ports all along the Italian coast. The Roman coast-towns of Dalmatia, from Zara to Ragusa, rendered him homage. He was rightly conscious of being Lord of the Adriatic and expressed this feeling symbolically by an imposing and beautiful ceremony. Every year on Ascension day, he — and after him the later Doges — went to sea in a magnificently decorated boat (the Bucentoro) and celebrated his espousal of the Adriatic by throwing a golden ring into the waters. Not that the rule over Dalmatia had then by any means been assured, or even after the Byzantine emperor had formally ceded Istria and Dalmatia to the Doge in 1074. The Venetians were, on the contrary, constantly forced to struggle against the rivalry of the Hungarians, and only enjoyed the undisputed possession of the East coast of the Adriatic after the time of the crusades.

Nothing is more significant for the character of Venetian rule, than its attitude towards the crusades. Venice, at that time, treated the Western powers like a cunning financier who supports an unpractical enterprise only to enable him to exploit all the parties to it. She was guided throughout by cold calculation and showed no trace of that holy, though blind zeal which has cost the crusaders of France and Germany no end of money and blood. The newly created Kingdom of Jerusalem had scarcely been established, when the Venetians came with commercial treaties, in order to secure new markets. They took care to be well paid for any assistance rendered to the frequently harassed kings of Jerusalem or to the crusaders, and did so most successfully on the occasion of the so-called fourth crusade, the intellectual leadership of which they conducted with incomparable skill. Their then Doge, the nonagenarian Enrico Dandalo, was the type of the inexorable, hard creditor, but also of the practical, carefully judging statesman. After the foundation of the Latin Empire he added to his title that of a *dominator quartae partis et dimidiae totius imperii Romaniae.* This high-sounding title expresses too little rather, than too much, for, apart from the East coast of the Adriatic, the most valuable coast districts and islands of Greece (f. i. Crete) became now Venetian property, partly through the treaty, and partly through special arrangements.

The support by Venice of the Lombard towns in their struggle against Frederick Barbarossa was not inspired either by ideal or patriotic motives. Only the interests of their financial politics induced the Venetians to counteract the preponderance of the emperor's power in the neighbouring Italy. And here

too their calmly calculating statecraft achieved a brillant triumph, since Emperor and Pope concluded in 1177 their famous concordate under its auspices. The Venetians devoted increased attention to Italian affairs, after having brought their Oriental trade policy to a certain conclusion at the beginning of the thirteenth century. Their object was notably to secure the very important trade in food-stuffs on the West coast of the Adriatic, the chief centres of which were Ancona and Ferrara.

Repeated wars helped them to achieve this object completely. Step by step the Anconates and the Ferrarese were deprived of all independent commerce, and a severe control exercised over the navigation on the Po and the Adige. Particularly admirable is the skill with which, in 1240, the Venetians united to a kind of holy war the most incompatible elements: the Margrave of Este, Milan, Mantua, Brescia, Bologna, Piacenza and the Pope, avowedly to subject Ferrara to the church, although the only reasonable advantage eventually accrued to Venetian commercial policy. Add to this, that King Manfred also had to make the most important commercial concessions to the Venetians, on behalf of his Southern Italian Empire, and the result is, that at the end of the thirteenth century the Adriatic could well be considered a Venetian domain. Already at that time Venice had attained such importance, that she had become the centre of a universal commerce which embraced the major part of the then civilized world. In the East her regular intercourse extended to the Sea of Azof and to Persia, in the South to the African coast, and in the North to the regions of the Baltic. Her merchandise was of the most important and valuable. Venice was the most important grain market of Italy and produced herself (in Chioggia) the greatest quantity and best quality of salt. It is true, that in the course of this glorious developement she had constantly to carry on struggles against numerous competitors whose interests were ever clashing with those of the Venetians in their most valuable commercial sphere, in the Orient. But here, too, after fierce fighting, a peaceful understanding was arrived at just at the end of the thirteenth century.

By no means the least cause of the great successes of Venice was the fact, that her domestic developement had on the whole been accomplished in the service of the interests of her national economy, though by no means without struggles. A system by which the people elect their ruler always ends in the long run in hereditary government or in complete enfeeblement of the monarchy. In Venice things took the latter course. From the earliest times the Venetion dukedom had had a strong democratic flavour. At the end of the ninth century the important affairs of state were decided upon by a *publicum placitum* which comprised, under the direction of the Doge, the higher clergy, the nobles and the people. Gradually the representatives of

12th century — the ecclesiastics

12th century — the ecclesiastics
the governing power remained
authoritative influence had at that
yet there had been a time, when
not have forcibly secured supreme
one food for thought, that in the
cipazio family wore the horned
y for the Doge to appoint his

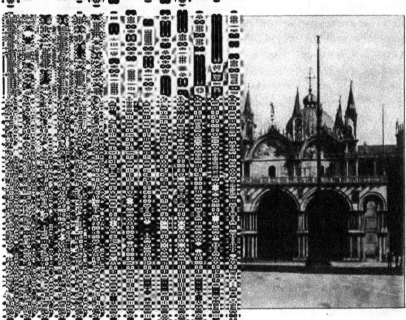

Mark's.

tow upon his relatives the most
provinces. It was a Doge,
these pretensions, in 1030, by
appointment of co-regents was
Doges restored to the entire
ge, who had been chosen by a
fore the people for acclamation.
ropped in the fifteenth century.
ight of choosing the Doge, now
e of all possibility of independent

action, even in the most unimportant matters.* Already at the end of the twelfth century the Doge shared the power of government with two aristocratic bodies, a greater and a smaller council, from which the Great Council and the Senate were evolved later. The supreme administration of justice was in the hands of the tribunal of the Quarantia. The administration of the property of the church of St Mark was, in 1207, bestowed upon six Procurators, a tribunal which, subsequently considerably increased and invested with new functions, became the greatest power of the Republic next to the Doge. The bodies politic that shared the government and were generally renewed by delegates, became more and more numerous. The leading idea in the entire developement of the constitutional history was a wise distrust, the endeavour always to control one tribunal by another. What the administration lost in simplicity, it gained by the extensive political training of the entire ruling caste. The deliberate statecraft of the *nobili* was unexampled in the Europe of that period. Not heated by any kind of idealism they transferred their cool manner of calculating and managing from their counting-houses to the palace of the government. — Two notable reasons will be found, if one inquires into the steady growth of this aristocratic rule. First of all, part of the nobility had inherited — as descendants of the formerly ruling tribunes — a claim upon participation in the government. Others subsequently acquired a similar claim by advancing considerable sums to the State which was frequently in severe financial troubles. It was quite conceivable and in accordance with mercantile views, that these creditors of the State were allowed a share in the administration, in which they were interested by their capital.

The Venetian aristocracy knew how to arrange with great wisdom its relations to the other two classes which had been excluded from all participation in the administration of the State: the clergy and the citizens. If the Republic suffered no priest to occupy any public office, she honoured the Church and her servants on the other hand in every conceivable way in matters of public worship. The greatest sacrifices were readily made for the acquisition of relics; the frequency and splendour of the Venetian processions were incomparable, and even the purely political memorial festivals were given a more religious character than in other parts. And withal this, considered merely superficially, it was exceedingly characteristic, that the patriarchal church (*S. Pietro di Castello*) was modestly equipped and situated at the remotest end of the town, whilst the church of the Doges' Palace was made one of the most sumptuous temple buildings of the world. — The aristocracy displayed towards

* The most convenient cause for reducing his power was offered by the so-called promissions, the comprehensive oaths on the constitution, which from the time of Enrico Dandolo (1192) had to be sworn by every new Doge before he could take that title.

the citizen class a benevolent protection; nowhere could the interests of the industrials have been better guarded. Whilst on the one hand a highly developed guild system advanced among the citizens that spirit of caste which penetrated the whole organization of the Republic, there was on the other hand a certain sense of liberality. Jews and foreigners could acquire the right of citizenship, and Venice soon became an asylum for the political refugees of the neighbouring countries, just like England or Switzerland in modern times — only, they were not allowed to interfere with the affairs of Venetian government. The political ambitions of the citizens were disposed of, by conceding to them once for all a few posts, the most important of which was that of High Chancellor.

If the developement of the Venetian aristocracy had been sound on the whole to the end of the thirteenth century, a false step was now taken by an act which proved to be fatal in its consequences. It was the so-called "Shutting of the Great Council", which was passed into law in 1297 at the instigation of the Doge Gradenigo. Those *nobili*, who since the last four years had belonged to the Great Council, were inscribed in the golden book, whilst delegates elected other members of the aristocracy to complete their number. Only the members of the families that were thus represented were henceforth to be considered as a ruling class, as eligible for the Council. Although this rule was subsequently sometimes deviated from, it still expressed in principle the isolation of the nobles, who were moreover exposed to all the dangers of decrease through the dying out of families and of degeneration through inter-marriage. Centuries, it is true, had to pass before these dangers appeared threatening. At first the aristocracy seemed newly strengthened. Unavoidable revolutionary attempts on the part of discontented noble families and pro-minent citizens were energetically suppressed. The Council of Ten (since 1315), a supreme tribunal invested with ever extending powers, guarded civil peace with iron severity. On one occasion even, when the two suppressed members of the Venetian state, the Duke and the common people, combined in a revolt, they could achieve nothing whatever. Marino Falieri's head fell in 1355 be-tween the columns of the Piazzetta and his partisans among the people were hung. A hundred years later, as proud a master-mind as the Doge Francesco Foscari suffered without a murmur all the tortures of the soul and the humiliations inflicted upon him by the victorious aristocratic party of the Loredani. More than that, he exhorted his only son to obedience, when he saw him wasting away, imprisoned and tortured. The Venetian nobility had become strong, not only as the ruling class, but also as the most important member in the economic life of the state. The wholesale trade and the shipping were still in their hands. And the *nobili* were at the same time the men to protect both, by wise council and also, sword in hand, at the head of their navies and armies.

Venice has often been blamed for her policy of Italian conquests, and it cannot be denied that the resentment of her injured and envious neighbours has finally become most disastrous for the Republic. Yet it must be admitted, that the Venetians could not well have taken another course, than that of founding an Italian territorial power. Their economic interests demanded it. At the beginning of the fourteenth century a number of sovereignties had sprung up in the neighbouring districts of Upper Italy, which, being all of illegitimate origin, could only be maintained by the most peremptory means of a brutally egoistic policy. The freedom of traffic and commerce, especially of the salt-trade, on which the prosperity of Venice depended, was constantly threatened, unless Venice met force with force. She had to posses territorial sway within her sphere of interest, in order to secure a voice in the general struggle for power, since peaceful political small-talk in the modern sense was here of no avail. There is this difference between the Venetians and their neighbours, that the former have never fought for dynastic interests or for vain greed of aggrandizement. They carried into all disputes that proponderating weight which results from wealth and stable government. In those times, when war was a trade, they could buy with their money the best troops and the best captains.

The first cause for interference in Italian affairs was offered them by the Lords della Scala who closed in their extensive Upper Italian state the navigation of the Po and burdened Venetian trade with duties. As usually happened later in such cases, the Venetians found allies in the neighbouring rulers; the Scala were beaten in 1338 and the district of Treviso fell to Venice. The most valuable allies of the Republic in this affair had been the Carrara, lords of Padua, and the Visconti, who had made Milan the centre of a considerable private power. The Venetians subsequently became involved in repeated struggles with them, for the same reasons as previously with the Scala.

The Visconti maintained their powerful position against the Republic; the Carrara, on the other hand, succumbed to the severe fate of the weak who has placed himself between two strong adversaries. Their domain became a prey of Milan and Venice, and the last ruler of their house, the aged Francesco Carrara, was executed with his son, in 1406, in the dungeons of the Doges' Palace. It is true, the Republic had strained her forces to the utmost, in the preceding vicissitudinous struggles. She had had to fight the Hungarians and Duke Albrecht III. of Austria, the allies of the Carrara. But the greatest danger was threatened for some time by her arch-enemies, the Genoese, who made use of the territorial feuds of the Republic, to try a decisive blow against her sea-power. When the Genoese admiral Pietro Doria had succeeded in establishing himself with an imposing fleet at Chioggia (1380), Venice seemed

lost for the moment. But the Signory decided in its extreme need to reinstate at the head of its navy the admiral Vittore Pisano, who had been put into prison for failures for which he had not been responsible. And when simultaneously a Venetian squadron returned from the Orient, the Genoese fighting power was forced to capitulate after a long investment. Since then Venice had no longer to fear the rivalry of the sister republic. She was recognized as the leading sea and colonial power of her time and proceeded now upon becoming also the leading territorial power of Italy. The annihilation of the Carrarese rule procured her possession of Padua, Vicenza, Verona, Bassano and Feltre. Soon after, the Republic acquired, in a successful war against the Hungarian armies of King Sigismund and the Patriarch of Aquileja, the whole of Friuli, and with it access to the trade-routes to Germany. About the same time Dalmatia, where the Hungarians had established themselves for sixty years, was definitely reconquered. The most valuable part of the littoral of the Adriatic belonged thus to the Republic.

The Doge Tommaso Mocenigo, who died in 1423, left his State in splendid prosperity. Venice then numbered 190000 inhabitants; her domain embraced over 42000 square miles; and the value of her trade was estimated at 10000000 ducats. A period of quiet prosperity seemed to be about to commerce for the state of St Mark, but fate gave it now a ruler, whose character became fateful to it. Francesco Foscari was unquestionably one of the most important men who have worn the *corno ducale*, and at the same time the last who has exercised a powerful influence on the general policy of the State, but he lacked that cool circumspection which had made Venice great. He needlessly forced the Republic into renewed interference with the affairs of the continent, against its most powerful state: Milan. An endless war followed, which swallowed enormous sums and stirred up the passions of the whole of Italy. It is true, Venice retained finally a new territorial addition, the districts of Bergamo and Brescia, which she had taken in the first years of the war. But it is very questionable, whether this gain outweighed the great losses, and the sum of hatred and envy that had accumulated against the Venetians. Twice Foscari had intended to renounce the dignity of his high office after transitory conclusions of peace, and both times he had been forced to remain. Now, after a reign of thirty-four years, he was deposed as a dead-broke man. He survived his fall only by a week.

His history has the moving character of a tragedy. With ardent ambition he had pursued the highest aims, and yet with his very name are connected the first symptoms of the decline of Venice. About the end of his reign the last remains of Byzantine rule fell into the hands of the Turks with the conquest of Constantinople (1453), through which Venice was brought into touch

with a dangerous neighbour. The rapacious Ottomans hat long disturbed the Levantine trade, so that in 1342 already a long war had broken out, in which the Genoese had fought on the side of the infidels, until they were defeated in a bloody battle at Constantinople. All the same the Venetians had reaped many an advantage from the disintegration of the East Roman empire. But now, when that buffer-state had disappeared, the Venetian possessions formed the next object of Turkish greed of spoil. The fear of the Turks has ever since weighed up on the minds of the Venetians. In 1463 the war flames broke out in Morea with the occupation of Argos by the Turks. At first, when Mahomet II. had sworn the ruin of the whole of christianity, the Venetians found allies in Italy and particularly in the Church; but as soon as their claims to power on the continent were remembered, they were left alone. Their great wealth and the undisturbed peace in their capital enabled them to endure elastically the heaviest blows of a sixteen-years' war, in addition to repeated epidemies of the plague. All the same they had to be contented with escaping with the loss of Scutari and payment of a considerable indemnity in 1497. Two years later, war broke out again in Friuli and in Morea, and though the Venetians had the support of Spaniards and French, they finally lost Lepanto, Modon and Coron, as well as parts of Dalmatia.

Whilst Venice thus saw her sea-power in the East shaken, she had every reason for pursuing her interests in Italy with all the more determination. In fact, at this very time the great prospect seemed to be opened to her, of taking the leadership in the confusion of the Italian system of states, and to prepare, if not to found, the unity of Italy. But the Venetians have not been able to rise to the height of such a task. Ever under the constraint of their economic interests, they missed the opportunity of re-modelling their half international commercial and industrial state into an Italian national state. Fate would have it, that just at this critical period the Signory was left without its circumspect political wisdom. During the period of foreign invasion, which now commenced, the Republic only pursued the most obvious advantages. In consequence she stirred up against her all the powers concerned, and conjured up the catastrophe which has sealed the fate of Venice and of Italy.

At first, it is true, the Venetians seemed to succeed in everything. In alliance with Sixtus IV. they made Ferrara completely dependent as regards commercial policy, and gained a few important coast-towns of Apulia. They even established themselves within the domains of the Church. For the losses in the Greek archipel rhey seemed to be indemnified by gaining Cyprus, which Caterina Cornaro had to cede to the Republic, as her obedient daughter (1489). The Venetians committed their first fatal mistake, when they witnessed in

inactive neutrality Charles VIII. the French King's expedition against Naples. They had hoped to derive benefit from these quarrels. Later, of course, the fear of further encroachments on the part of the French induced them to join the so-called Holy League which allied Milan and Naples to Maximilian and the Pope. But when it was speedily discovered, how unreliable the Duke of Milan and Maximilian were as allies, it was thought advisable to take the side of the French, when they once more crossed the Alps under Louis XII, in 1498. The subjection of Milan, which was the object of the King, could only be of advantage to Venice who actually retained the districts of Lodi and Cremona after the fall of the Sforza rule. She subsequently adhered to the unfortunate alliance with France and consequently made an enemy of the emperor Maximilian whom she prevented by force from his intended invasion of Italy in 1508, and from whom she actually took some strips of frontier land by force of arms. Meanwhile the Signory had made a bitter enemy of the new Pope, Julius II, by obstinately detaining the occupied towns of the Papal State and thus fatally underrating his character. — The wise Signori in the *palazzo ducale* relied too firmly on the difference of the interests of their opponents, and seemed to overlook the fact, that their French allies were only awaiting an opportunity to attack them by surprise. And thus it happened that the Republic had to face unprepared the combination of the three powers in the League of Cambray, which was now joined by all the Italian grudgers and enemies of Venice. Her troops were beaten in April 1509 at Agnadello, and at one blow she found herself deprived of almost her entire *terra ferma*.

The Republic was deeply humiliated, and if in the end she regained her possessions, this was due less to her own strength, than to the superior judgement of the Pope and to the loyalty of her old subjects. But henceforth the glory of Venice was a thing of the past. She fell into the condition of the states which no longer have any high aims to pursue, and all her admirable political wisdom worked only for the maintenance of existing condition. Her outward splendour remained nevertheless undimmed for a long time yet. More than that, the Levantine trade took a new lease of life during some decades of peace with the Turks, and the consequences of the discovery of a sea-route to East India asserted themselves only very gradually. All the arts flourished in the asylum of the lagoons and decorated the town with that sparkling, magnificent dress in which we admire her to this day. Venice, who had always loved to celebrate fêtes, became the greatest centre of pleasure in Europe, and we do not hesitate to admit, that the pleasures, which were here sought and found, were by no means merely sensual. The aristocracy, now retired from business, cultivated literature and science. Now, in

the sixteenth century, full atonement was made for the former neglect of higher culture, and Venice became a centre for the rich culture of the renaissance — different, it is true, from Florence, Rome or Ferrara, but no less important. In this connection it is a characteristic trait, that Venice became the most renowned printing centre of Italy. It was just that the Venetians understood .how to make a business of science, as of every-thing else.

With Italy they lived henceford in peace. The unruly tyrannies of yore had partly disappeared, and partly become consolidated as legitimate principalities. The Pope and the Spanish vice-regents at Naples and Milan had the same interest in maintaining peace and order. Once only the relations between the Republic and the Church were seriously shaken, in 1606, when Pope Paul V. interdicted Venice for having imprisoned two criminal ecclesiastics. Only after the lapse of eighteen months an agreement was made, by which the interdict was annulled and the ecclesiastics set free "by way of exception". For the rest Venice maintained all her rights and prerogatives against the Church, and notably enforced the banishment of the Jesuits from her territories, which had been decreed during this dispute. The year 1615 witnessed a war against Austria, caused by the latter country suffering the Uskok pirates to violate Venetian rights. But here also, after two years, the Venetians concluded a peace which was at least not disadvantageous. — Turkey alone constituted a great, threatening danger to the Republic during the last centuries of her existence. It was the Levantine trade of the citizens, which, together with the landed property of the aristocracy, had remained the sole source of Venetian prosperity. For a long time yet the Republic fought against the Turks, with glory, though not with good fortune, and many a *nobile* gave new splendour to his old name, as admiral or captain. Nevertheless the decline of the moral strength of Venice was not to be checked. By herself she was no longer a match for the infidels, since her defensive force did not consist in her brave sons, but in her good gold-pieces. Thus crumbled away, one by one, the most valuable parts of her colonial possessions. First Cyprus was lost in 1570 and was not retaken, although in the following year Don Juan of Austria annihilated the Turkish sea-power at Lepanto. After a long peace war broke out again in 1645 for the possession of Candia. The Republic strained her resources to the utmost; she humiliated herself to the extent of a wholesale barter of her titles and offices; moreover the Pope allowed her the tithe on all her territories. A whole succession of heroical captains-general have commanded her fleets in the course of the twenty-four years' war. Amongst their number Battista Grimani, Lorenzo Marcello and Lazzaro Mocenigo fell facing the enemy, after brilliant successes. Yet Candia could not be held and

...e was concluded in 1669. —
...past greatness, when, in 1684,
...or and the king of Poland for
...itary enemy. For some time
...Morea from victory to victory.
...ustom of antiquity, had given
...y demanded and achieved his
...naries, Count Königsmark, had
...r had fallen and Morosini had

...ork's.

...me time. But in the end the
...Thus Venice presented herself
...ping of the eighteenth century.
...he inner disintegration of the
...ent, when, in 1713, the Turks
...reconquer what they had lost.
...without a sword being drawn.
...Corfu was only held by a
...Even he could not have spared
...not Venice found an invaluable

ally in the German emperor. Thus a tolerable peace was after all concluded at Passarowitz after Prince Eugene's great victories at Peterwardein and Belgrade.

On the whole the Republic of St Mark has only just vegetated ever since. For the political world she was surrounded by a reflection of the halo of her old, proverbial statecraft. For the world of pleasure the lovely town became a favourite rendez-vous. The *vie galante*, which can here be so thoroughly enjoyed, received its seasoning through all manner of local peculiarities: the expeditions in the gondola, the constant wearing of masks, to which was added a harmless, creepy fear of the mysterious powers of the state-inquisition. The outer frame of this life with its faded splendour commenced also to be considered from the romantic, sentimental side. In a political calm the decayed edifice of the Venetian state with its partly senile, partly frivolous conditions might have existed for a long time yet, since the government was wise and just in its own way; but everything collapsed at the first storm. It is now just a hundred and six years, since the Napoleonic general Baraguay d'Hilliers occupied Venice (1797), since the golden book of the aristocracy was burned, and drunken wenches danced the carmagnole on the Piazza around the trees of liberty.

Since those days the fate of Venice has undergone many more changes. But here we need not speak of them, for all these changes have found no echo in the art of Venice. Nor could they have done so, because Venetian art had died with the Republic.

————

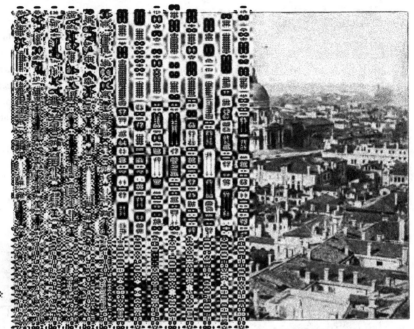

(... i Mare and S. Maria della Salute.)

...RCHITECTURE.

... of a strange and curious town
... iew, as it were. Only when he
... in loose outline, he proceeded
... ose proximity. We will try to
... short examination of Venice.
... aspect of a town: first of all its
... of its inhabitants. In Venice
... fashion, than anywhere else in
... a group of little islands in the
... the largest island was called
... ro, Luprio, Gemine, Mendicola,
... nt Giudecca. Freshwater springs
... ins a rich proportion of shell-lime.
... ents of ebb and tide prevented
... m becoming injurious to health.

2

...d to these islands in the early middle-
...althy and protected settlement. But the
... although, for centuries after, soil could
...ns. The most popular of these gardens
...midst of which flowed the Rivo Batario
... the Doge Sebastian Ziani. A mighty,
...re now the clock-tower stands, and in
...e, to which the horsemen used to tie
...er allowed to trot through the narrow

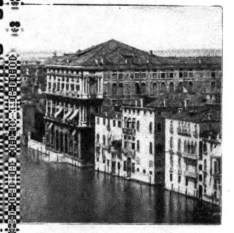

... the right the Palazzo Corner della Cà grande.

...land became insufficient for the rapidly
...building into the water on dense piling
...the marshy ground. Where the building-
...e naturally crowded close together and
...longitudinal direction. But as the water
...chief means of communication for every
...gradual completion of that close net of
...in every direction. The streets, which
...served exclusively for foot-traffic, and
...le in most of them to touch the opposite
...e's arms. A brilliant satirist has called
...en anchored for thirteen centuries", and
...fail to strike everybody who first finds

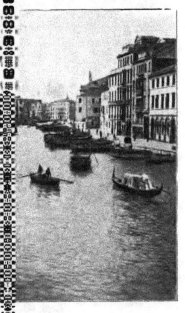

It stands to reason that these
ons for a developement of archi-
one achieve monumental effects,
if space is lacking everywhere?
on became decisive for the de-
her fine arts under such peculiar
d by merchants and seafarers.
atic constitution of the common-

anal.

ent individual activity, than any
helped, on the other hand, to
only in the interests, but also in
enice never lent herself to those
he charakter of a fortress even
al edifices took here the exclusive
places of confraternities. The
which also took a hold on the
nly the memory of saints or of
by splendid monuments in the
rendered less to the personality

he had served — religion or the state. ... thing interfered with the enjoyment of ... eans which were not allowed to serve ... rcantile class is always and everywhere ... material wealth, the Venetians showed ... direction. The Orient, with which they ... taught them many a habit of comfort ... terwards with the innate refinement of ... Venice was already considered the town

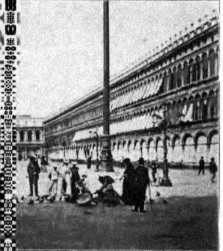

... from the church of St Mark.

From such inclinations one cannot so ... alted and serious direction of art, as the ... which lend gayness to life: decoration, ... age.

... ce, as we still see it to-day — how ever ... of all other towns — is in itself entirely ... fortable dwelling-house, the palazzo, is ... to the last centuries of the Republic. ... in the upper story, called *liagò* in the ... owards the South, if possible, and with ... right. Later, beginning with the twelfth ... is formed as an open gallery, called

...rated by a wall with windows. ...mercial intercourse, appears again ...ally divided by an inserted floor ... On the second floor, to which ... arrangement of the first floor is ...ed towards the canal, the back ...reet. An outside flight of steps ... of the first floor. Truly remark... house was distinguished in the

before the fall of the Campanile.

...te of space. The chimneys were ...provided with cranes which lifted ...The flow of the tides in the canals ...not be surpassed by the artificial

...was traversed by one single, broad ...s throught the town in the shape ...n plenty. The proudest *palazzi* ...this day it has remained, what it ...n ambassador Philippe de Comines ...t its beauty lies not alone in the ...ch are reflected in its waters, but

's of the canal. The straight direction
the practical point of view that the
no esthetic reason. The straight road
for in the same measure, in which it
he open end of the street, it prevents
t both sides. The *Canale Grande*, on
cture, the frame of which is sometimes
closed. Its palaces impress themselves

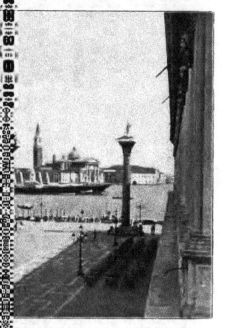

he Piazzetta.

y, notably because from every point of
ne of them.
g the most beautiful street, she also
he *Piazza* likewise preaches a chapter
(fig. 10, 11). It clearly demonstrates
y a place of concourse, but also a place
to the point of considering a Square
nt thoroughfares, and therefore not as
ll sides, a space furthermore, in which
e traversed as quickly and carefully as

It surrounds us like a hall

and whoever does not know

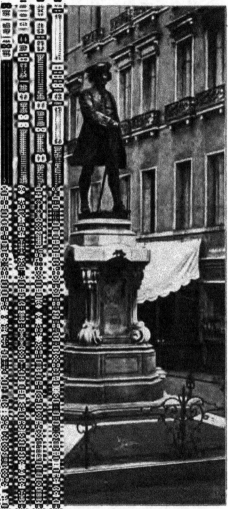

Fig. 13. Carlo Goldoni.

isposition has no match in the

rene splendour all the inventions

Squares; only at the end in front of
on the most beautiful of all pedestals,
two enormous monolith columns which
nts of the Republic. In fact, the only
times on a public Square in Venice, is
Paolo. Here too is food for reflection
til we have built a monument in the

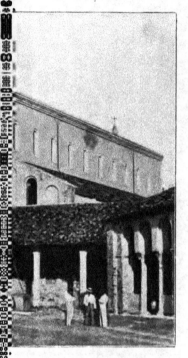

the foreground the Bishop's Throne.

must, of course, be placed in the centre
not only the face, but also the back,
time — in the seventeenth and eighteenth
monument was so composed as to offer
The spectator was thus forced, to circle
y it. Our sculptors have felt the esthetic
d, and content themselves again with
m to be less aware of the fact that, in
have to place the monument in such a

...rom the principal side. Thus in
...tance from the famous men in
... would-be-great, rides about with
...aniele Manin, Garibaldi, Goldoni
...the middle of Squares. Popular
...ommaseo by the famous Milanese
...to's Goldoni, which is altogether
... good in so far at least, as it
... of the crowd which he himself
...how is the Colleoni placed? —

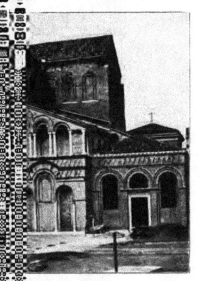

...no. Exterior of the Choir.

...y; but it forces the beholder to
...es him to the spot, from which
...e the figure also gets its proper
...rch.

...e aspect of the town of Venice:
...ngs, have their principal aspect,
...nfortunate impulse of mistaken
...idea, that it is necessary to rid
...eel them out", as the fine phrase
...times beneficial to archaeological
...finest buildings in Venice, only

, and even it in a very limited sense,
being turned towards narrow streets.
Even more hidden are S. Giovanni
A number of the most interesting
ply their front (f. i. S. Maria dell' Orto,

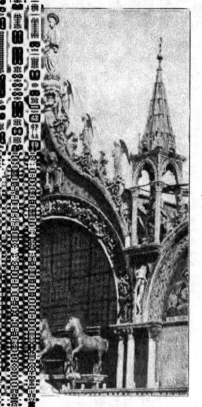

on the Façade of St Mark's.

yet, as far as I am aware, nobody has
cled out, in order to be better appreciated.
" belong to the Church. But to see them,
boat on the lagoon, to Murano and to
njured as yet, some thousand years old,
, with nave and aisles without transept,
atrium before the main entrance. The
ongs in its essential parts to the ninth

...e interior are perhaps remains
...d of the wall-surface the surly
... interior: the Crucified Christ
...semi-dome of the apse. Very
...rising from amidst the semi-
... of columns, which supports a
...abs in clumsy relief, separates
...uring church of *Santa Fosca*
...rch architecture. The principal
...ut is at present protected by

... the Vestibule.

...e very short transepts of equal
...co with its surmounted circular
...back to about the end of the
...the glassblowers' island *Murano*,
...interior (originally a basilica),
...(fig. 15). The double row of
...nd round the polygonal choir
...green marble and yellow-red
...tectural pictures of Venetian art.
...n has here been advantageous
...n inscription in the mosaic floor
...he year 1111. Most characteristic

...occidental plan of the building and the
...e very stilted circular arches and the
...walling. Again and again we shall come
...hole course of mediaeval architecture in

...picturesque churches is however only
...ssion of St Mark (fig. 5, 16—20). Let us

...f St Mark's.

remain facing the front. The wonderful building seems to belong to none of the known styles. The incredibly fantastic splendour of the façade immediately holds one spellbound, and only when his eye has had its fill of the unusual apparition, does the beholder feel the critical endeavour to account for the reason of his delight. And then he makes the remarkable discovery, that here, where his feeling praises everything loudly and emphatically, his examining reason has to find some fault everywhere. First of all he must admit that the effect of this façade is far more pictorial, than architectural. If the forms of the building are considered as such, one will find again

...n. Why is the wall divided into two
...wding of columns? Why is it, that the
...ave to cut twice across a cornice? On
...cupolas disappear from view, one might
...five-aisled basilica, like, say the Cathedral
...eading. And if you now consider the
...apposition of the kind that will often
...able jumble of the forms of style of all

...nce, interspersed with oriental ...ry possible mediaeval variation ...e basket and lattice patterns; ...ate probably from remains of ...appears sometimes the modest

St Mark's.

...nes the stilted arch (the three ...now simple (on the two outside ...eepers (on the five pediments). ...ne left probably date back to ...oining mosaics of the next niche, ...renaissance. The oldest of the ...above the centre of the portico,

which came to Venice with the loot of the fourth crùsade (fig. 18). The reliefs
on the first and third arches of the main porch must date back to about the
turn of the twelfth century, and the rich and delicate bordering of the niches
above them, with tendrils and dainty figures leaning towards each other, to
about a hundred years later. Finally in the fifteenth century the architect of
the Doges' palace, Bartolommeo Buon, crowned the pediments with that
wonderful cornice of statues and diversified foliage, from which saints and
angels are rising, and placed by its side the tabernacles with the figures of
the Evangelists, the angel and the Virgin of the Annunciation (fig. 16). — The
value of the infinitely diversified details varies, of course, considerably; some
parts, like the mosaic in the portal-niche on the left and the Gothic sculptures
of the pediment, belong to the best of their kind, and the even splendour of
the material is so dazzling as to hide the inferiority of many other details.
If one looks over the whole building, one would not wish to see any part
altered, for every bit relates a piece of history.

The effect of the interior forms the most striking contrast to that of the
exterior. After having crossed a narrow ante-temple covered with dome-
shaped vaults, you enter a hall which is as surprising for its size, as it is for
the evenly toned quietness of its decoration.

The mighty effect of vastness is based first of all on the simplicity of
the plan: five cupolas arranged in the shape of a Greek cross and the spaces
under each cupola surrounded by narrow side-aisles. In the Western, Northern
and Southern transept the side-aisles are separated from domed part by rows
of pillars, above which extends a gallery. — A further reason for the grandeur
of the effect is to be found in the smallness of the profiles, which almost
amounts to poverty. Imagine the dome rebuilt in baroque style, with the far
projecting profiles of the late renaissance in the place of these meagre imposts
and arched mouldings, and the whole room will immediately shrink together.
This is not the place to discuss the esthetic law, on which this effect is founded.
As a test I should, however, recommend the church of St Peter's in Rome,
the interior of which, as is generally known, does not by any means immediately
produce the effect of its true, gigantic size. The chief reason is undoubtully
to be found in the colossal forms of the separate architectural parts.

To the beauty of the spatial effect is added at St Mark's the multi-coloured
splendour of the decoration. And these mosaics with their golden backgrounds,
which cover all the domes and arches and the higher parts of the walls, do
not in the least reduce the impression of grandeur of the whole, because they
lose themselves in the general effect of colour. The key-note is given by the
warm and dull brown of the marble, which goes splendidly with the gold
decoration. Other kinds of marble, red, green, veined with black and white,

...atterns cover the floor. (Most

...ch of St Mark has become a

...for, indeed, there is scarcely a

...picturesque aspect in whatever

...ound-plan of the church contains

...pses, which terminate the East

...of the West transept, make it

...Mark's.

...ns of an original edifice in the

...rch of St Mark has been partly

...t was afterwards, in the eleventh

...elvo, rebuilt, and was probably

...rch after the Byzantine example.

...stood for centuries under water,

...e twelfth century, the vestibule,

...enth century, was added (fig. 19).

...must first speak of the little

...he second pillar of the left aisle

...ted on the Piazza and was only

end of the thirteenth century, after a
upon it. Probably of about the same
ur columns of the tabernacle over the
series of reliefs from the history of the
ring-shape. The front of the high altar
e famous *pala d'oro*, the finest production

of the Pala d'oro.

her part dates back to the tenth century.
d the figures of S^t Mark, the Virgin and
end of the fourteenth century. The
decoration of the Cappella Zen, whilst
the eighteenth century. The oldest of
(with the exception of the Southern one),
a Zen show the Byzantine style with the

nth to the thirteenth centuries.
great merit of fitting excellently
unded. And the same cannot
d, although in some cases the
the designs for them (f. i. Titian
he left aisle).

c has never ceased decorating the
period has offered the best and
sparing in most cases what had
baroque art did venture upon

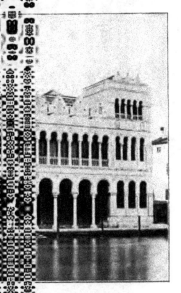

ndaco de' Turchi.

completing its mosaic decoration.
ained without any influence on
cture. Only in the renaissance
as again referred to. Altogether,
cture, that have been preserved
the additions of later centuries,
day far more is to be seen of the
must be admitted, mostly in
esque palaces, now arranged as
its old walling. The brilliant

3

a few decades ago, although the old
...part of the two storeys is devoted to
...und-heads. Eighteen arches on the first
...and-floor. To the left and right of the
...et into the wall of the ground-floor and
...gular, pierced battlements crowned the
...century was the palace used as ware-

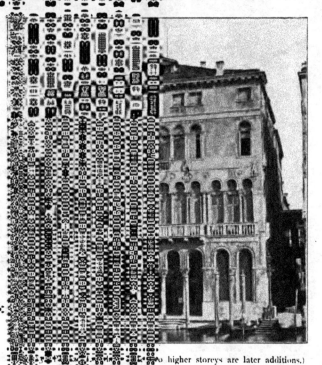

...o higher storeys are later additions.)

...The same type of two-storied, colon-
...ces of the Grand Canal by the present
...) and by the *Palazzo Businello*, all of
...additions. On other palaces of this
...o Sti. Apostoli) we notice above the
...tracery, entirely in the shape of the
...must by no means be taken as a proof
...style. It is, on the contrary, a purely
...h, it is true, was taken up by Gothic

...ay have been built about 1200,

...by a different route, in the train
...han we to day form an idea of
...xercised upon their time by the
...Thus much is firmly established:
...e thirteenth century is marked
...his grave for two years, when,

...ari. Interior.

...n was commenced of the church
...The plans had been designed
...othic church architecture became
...Dominican churches which soon
...towns received the simple monks
...contributed their mite towards
...me so abundant, that the severe
...regard to their buildings, were
...hes of the mendicant orders in
...aolo offend seriously against the

3*

dimensions and their vaults, and the
But as far as the essential features of
ize not only with each other, but also
s: the Latin cross of the ground-plan
which is accompanied by a series of
of Venetian churches are the column-
aisles from the nave, the equal number

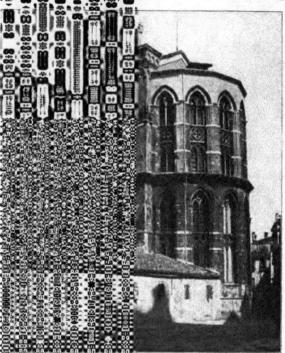

of S. Maria dei Frari.

s, and the polygonal termination of the
chapels. Much as we appreciate the
or, especially in the Frari, we yet feel
ches. The Italian has never known how
the Gothic style for the decoration of
with its high windows decorated with
vivid effect; the bare façade is imposing
urved tops disfigure the gable, and a
stands, quite unexpectedly as it were,

similar porch, more sumptuous ... ut, is that of *San Stefano*. (Here ...d. The cloister with its too ...ce). The front of S. Giovanni ...he magnificent porch suddenly ...work from the period of the ...the second half of the fifteenth ...mains now the most beautiful

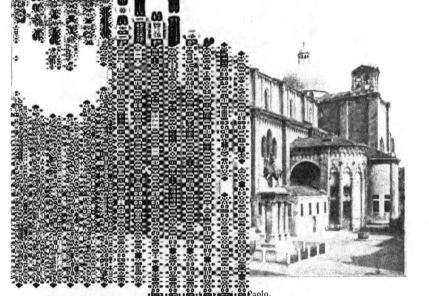

...Paolo.

...few promising fragments are ...windows of the aisles, the dainty ...ns of the whole building, give ...hich the fronts of those larger ...st be added the rich, figural ...d in the tabernacles, probably a ...ed to later (fig. 27).

...e destined to achieve its best, ...has here given the physignomy

...eatures. The Venetian palace, as it is ...rld, is the Gothic palace. It is true, this ...of our Northern cathedrals and town- ...closely connected with the Orient. This ...that it has tempted some art erudites ...claiming the Oriental origin of all that

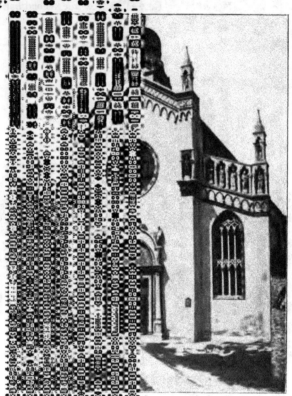

...Maria dell' Orto.

...ons and in its forms the Gothic style is ...s of Venice, with their firmly established, ...ny new constructive problems. Anything ...from the new forms, without their meaning ...ere used playfully for purely decorative ...al articulation was decidedly accentuated. ...semicircular arch, or incrustation. The

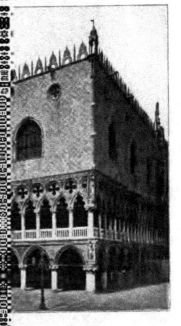

permitted, for preference in the
known from the Orient. The
lating creeper; the cross-flower
natural that the declining Gothic
self better to such intentions,
nd thus we find the bloom of
th century, when the elements
disintegrating the Gothic forms.

alace.

ure is accompanied by a monu-
ce and in its historical importance
oges' Palace — another building,
ch makes it exceedingly difficult
would dare to speak of faults,
lives in the imagination of the
y notions about the articulation
the literal sense of the word.
for esthetic reasons, that the
whilst the upper storeys should

about. Two arcades support a mass of ...es together, and interrupted only by a few windows. Furthermore the proportion of the two arcades to each other is so improbable, that for a long time it was believed, that a good portion of the heavy, baseless columns of the groundfloor must be buried in the ground. But this is not the case. The columns never were higher than we see them now. It is nevertheless significant, that soon after the completion of the building the disproportion was felt and boldly corrected in the pictures of the painters who were then more ingenuous that at the present day. In most of the old pictures and wood-cuts of the Doges' Palace we find the ground-floor heightened and the upper wall shortened.

· The history of the Doges' Palace is closely interlinked with that of the Republic. Immediately after the seat of the government. had been transferred to Rialto, the erection of a Ducal castle was commenced. Of this building, it is true, no traces are left to-day. What we see, dates back in its oldest parts ...efore 1340, the two arcades were built, ... by the present *ponte della paglia*. The

to remain behind it. The con-
interruption of the works. One
among the guilty and was hung
that at that time a decree of
for speaking of the continuation
Doge Tommaso Mocenigo took
it possible to recommence the
ntradicted by the date of 1404

the Doges' Palace.

windows on the South side, a
this may be, the artists' family
ctory completion during the first
lla carta, commenced since 1439
ion, was the final touch (fig. 29).
— gem of late Venetian Gothic
ance motifs.
ough a dusky colonnade into the
surprise in store for him. Here
as erected the most sumptuous

marble structures along two sides of the wide court. The building of that
hall behind the *porta della carta*, and notably the tower at its end, the so-called
torricella with its curved roof and the many pinnacle-like obelisks at both sides,
has still many a Gothic motif. And also the beautiful gallery with its pointed
arches on the upper storey of the palace repeats some mediaeval motifs, but
yet a new and more brilliant style triumphs everywhere. Three masters have
here joined hands: Bartolommeo Buon built the *torricella* after a fire in 1477;
Antonio Rizzo, the worthy sculptor, commenced soon after 1480 the two lower
storeys of the East wing and carried in 1498 the *scala dei giganti* up to the
apartments of the Doge, so that the prince might from here descend in solemn
procession in the eyes of the people; and finally *Pietro Lombardo* (since 1499)
added two richly decorated storeys with windowed fronts to the two halls and
erected the façade in front of the Capella San Clemente behind the giants'
staircase. There was sufficient difference in the style of the three masters:
the fresh Rizzo counterbalanced the more ponderous Buon, and the two were
joined by the dainty Lombardo, the master of Venetian jewel-box architecture.
And yet all the three were united by that ingenuousness, that joy in things
beautiful, which youth and the early renaissance have in common. Some parts
were completed about 1550 by *Antonio Scarpagnino*, f. i. the decoration of the
three arcades behind the upper landing of the staircase. He has also changed
the arrangement of the windows on the façade turned towards the canal. The
Doges' Palace has thus retained the external appearance which it was given
about the middle of the sixteenth century. A danger, with which it was
threatened after repeated fires (1574, 1577), was happily averted. Palladio, to
wit, recommended a thorough alteration of the damaged building in the sense
of his severe late renaissance style. But fortunately the Signory decided in
favour of the opinion of Antonio da Ponte who subsequently restored every-
thing with great discretion and admirable skill. Finally — about 1600 — the
so-called *Bridge of Sighs* was added, built by *Antonio Contino* between the
Doges' Palace and the prison (fig. 52). The Gothic façades of the Doges' Palace
found an echo in the entire private architecture of Venice. The tracery of the
arcades, the coloured patterns of the walls, the twisted corner columns, the
battlements — everything was repeated and modified a thousandfold. The material
employed was at first more simple than heretofore. The builders allowed an
ample amount of the brick-wall to appear; they made more sparing use of
incrustation, and tried altogether to replace by colour what was lost in
preciousness of the stone. In one essential point these Gothic façades deviate
from the older ones: a short loggia of few arches is placed on the upper
storey, instead of the colonnades on both storeys. The colonnade on the
groundfloor disappears. By the side of the porch appear here generally the

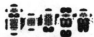

...fect only gains consequently in
...this day we find this type in
...eginning from the present Hotel
...Only a few particularly inter-
...crowd. The simplest form of
...ve the loggia — is presented by
...*Sanudo-Vanaxel*, close by Sta.
...*nolesso-Ferro* (now Grand Hotel)
...ingly and cut off immediately

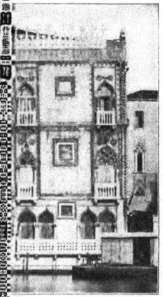

...loped loggias can be found on
...and on the *Palazzo Giovanelli*.
...monumental in size. The latter,
...the first bend of the Canal, also
...reatment of the loggia, which is
...the ill-fated Doge Francesco
...ws of quatrefoils one above the
...elo Raffaele. Among the small
...*ntarini-Fasan* is famous for the
...s. The jewel among all these

most Venetian of all Venetian palaces,
onal monument, as it were, by its owner,
lligent restoration had to disfigure the
w of balcony-windows in the place of
that at the same time a row of pointed
efective at is was — was replaced by a
nly regrettable. Nevertheless, a more
charming sight cannot
be imagined, than this
small, gaily coloured
marblehouse with its
daintily chiselled win-
dows and arcades
above the green mirror
of the Canal. (The
direction of the build-
ing, on which a vast
number of stonecutters,
including Lombards
and Tuscans, were
employed together,
was in the hands of
Giovanni and *Barto-
lommeo Buon.*)

A long time had
to pass, before the
renaissance could esta-
blish itself and conquer
completely in Venice.
What Venice lacked,
was the comprehension
the great movement of culture, which
The free developement of individuality
regimen, and the passionate enthusiasm
faint echo in the circle of the splendid,
The only channel, through which the
unobstructedly at an early date, was
ulptors, goldsmiths and painters, hailed
rushed upon them. But they were not
of the new style. With all the freshness

ure of forms, without inquiring
strict of Italy, therefore, is the
and jumbling of styles, as in
existance for a long time, in

caria.

but few exceptions against the
ten Romanesque, nay Oriental,
trical circular patterns, gracefully
ral tasks the examples furnished
ches were repeatedly fallen back
of the fifteenth century marked

of the Republic. Orders were plentiful
use of precious stones for incrustation.
ment on the many buildings which were
to 1540 approximately. It depends on
rtain: they all without exception are a

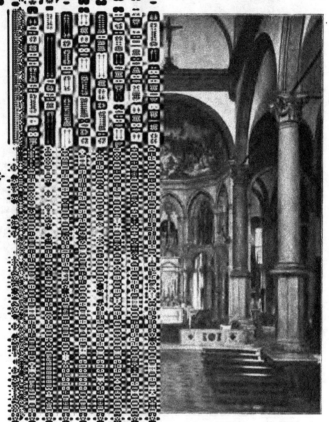

Fig. 3. Interior of S. Zaccaria.

ed, superficial observer. He, on the other
ent styles and loves a clear, architectural
everything. He may, in the face of these
rightly find fault with the "cabinet-makers'
ch dissolves every architectural form into
admit this, and yet love and praise the
that all architecture is a growth of its

or of the water — this cannot
produce its effect from close
not produce an effect at a
e. A Romanesque chancel
Campo San Zaccaria. And
the Lombardi, Bergamaschi
the last thoroughly Venetian
anywhere else in the world.

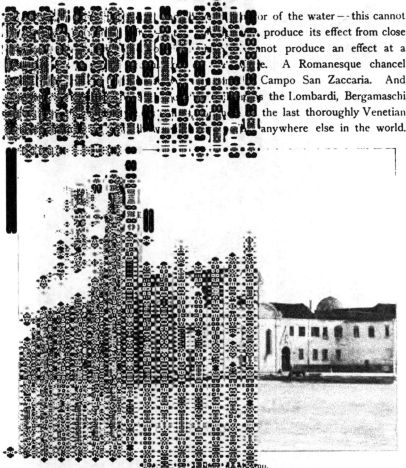

of the late renaissance, headed
the lagoon quite early enough.
age over that of the earlier
sonalities who direct the de-
of monuments. It is above all
of a numerous tribe of artists,
s on sculpture. His cognomen
lace derived their renaissance.
the church of *San Zaccaria*
certainty be credited to any

54). A certain *Antonio di Marco Gambello* ... to the year 1477. He commenced the ... gonal and with a gallery, and also the ... loured, incrustated panels and the twisted, ... The further building was, on the other ... he early Venetian renaissance; the domes

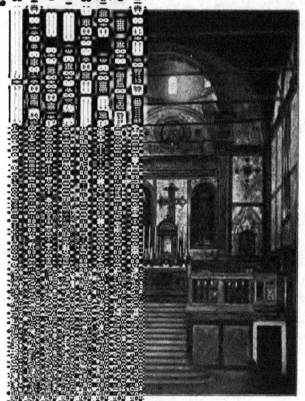

... of S. Maria dei Miracoli.

... the radiating chapels, and particularly the ... lely for the sake of decorative effect, and ... ches and windows, it presents a type of ... The semicircular termination of the pediment ... termined the entire course of this period ... the stone in flat and plastic ornaments ... nely neat and pleasing. — A similar façade,

...at of the cemetery-church of ...nore attention should be given ...Western vestibule from the body ...iliana by *Guglielmo Bergamasco* ...h to the exterior. Façades of ...(with a splendid porch) and on ...urches deserve special attention

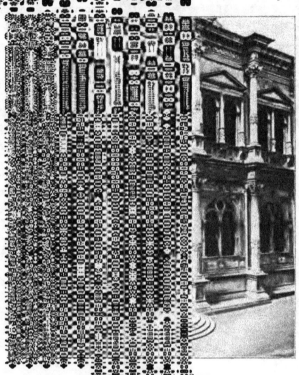

...Rocco.

...ed on the pattern of St Mark's ...S. Fosca in Torcello, S. Giacomo ...ated fairly exactly in *S. Giovanni* ...n the means at the disposal of ...ement of the same idea is in ...do. Completed in its chief parts ...e building, in the purity of the ...te renaissance.

the pilasters which lean against main
ed interior is permeated with the spirit
ffers perceptibly from the interiors of the
tedious baroque façade dates from the

rches can compare with *Sta. Maria dei*
ed homogeneity of the general aspect.
in one piece as it were. As the habitation

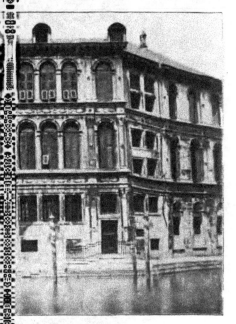

o dei Camerlenghi.

it was built by *Pietro Lombardo* in eight
which flowed in profusely. Seen from
uary on a grand scale. Especially the
suggests the lid of a coffer. The outer
s on a light ground, between which the
uite unnecessarily, in geometrical patterns.
red ceiling under a barrel vault, has no
e; by the entrance is a nuns' choir. The
rnaments by which all panels are covered,
ists. From 1505 to 1515 *Pietro Lombardo*

...n the church of S^t Mark. His

...ons, which were called *scuole* in ...d the secular buildings. According

...oli in Venice.

...with generally only a few side-
...e finest among them belong to
...given to the *Scuola di San Marco*.
...oined at right angles, the longer
...on the canal, whilst the South

ade, adjoins the church of S. Giovanni
pendant to that of San Zaccaria. The
closed in, an arch on an all too slender
liarity are the reliefs in perspective on
but only trivial things withal. — Only the
preserved of the *Scuola San Giovanni*
ikewise a building of Pietro Lombardo's.

Palazzo Dario.

Evangelist in the lunette of the arch.)
rs in a higher stage of developement in
by *Santo Lombarda*, but finished in its
carpagnino (fig. 37). The cabinetmakers'
ly conquered, and every part shows the
ntelligent design of the decoration. The
the two-storied façade, have an equally
the shape of a wreath of leaves, which
mitigates its excessive slenderness. The

groundfloor into two smaller
othic tracery. The pretty motif
s. The general impression of
her two buildings of Scarpagnino,
vecchie di Rialto fall curiously
style. More graceful, and yet
alazzo dei Camerlenghi near the
8).

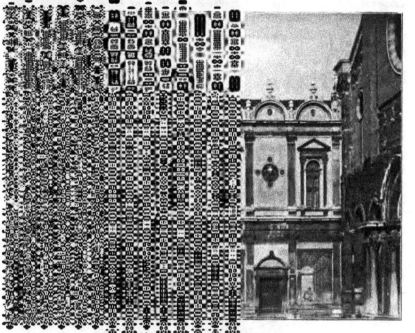

(Hospital).

Palazzo Dario (1450) represents
ayful incrustation and ornaments
nsoni and *Contarini delle figure*,
the foot of each storey, belong
in coloured disks and shields.
coupled arched windows of the
i Corner-Spinelli and *Vendramin-*
tinctly articulated by enormously
since 1481 by *Pietro Lombardo*,

probably after plans by *Moro Coducci*, is the largest and finest of the whole group. Put together with firm columniation, it yet almost seems to float above the mirror of the water, with the light rows of arches of its upper storeys. Its roof is sacred to lovers of music, for under it Richard Wagner breathed his last.

During the early renaissance period the Piazza, too, was given on the whole its present shape by some new buildings. *Bartolommeo Buon* seems to have been the leading architect. First, in 1466, the pilaster-building of the clock-tower was commenced (completed possibly by *Pietro Lombardo*). Soon after, the *old Procuratie*, the official quarters of the Procurators of St Mark and offices of numerous authorities, were erected. Both buildings are of comparatively small innate merit. Some parts, such as the trumpery battlements on the main cornice of the Procuratie, are absolute faults, and yet one could not wish for a more distinguished and quiet framing for the square, than the long arcades of this building. The eye passes over them, undisturbed until it finds a resting-place on the magnificent picture of San Marco. Whilst the part played by Bartolommeo in these two works is not quite clearly established, we know for certain that he was the master who completed the *Campanile* of the church of St Mark. The smooth stone-obelisk, under the weight of which the bell-loft with its arches seemed to shrink together, was perhaps in itself clumsy, and yet it formed the best crowning of the mighty shaft of the tower. Recent careful investigations of the foundations of the Campanile have revealed some weakness which may cause a new site to be chosen for the new building. — One more building of this period must here be mentioned: the *Fondaco de' Tedeschi* (now General Post office) by the Rialto bridge. True enough, it is now a bare stone-cube which is only given life by the openings of the windows, but once, when Giorgione's and Titian's frescoes adorned its walls, it was perhaps the most beautiful house in Venice.

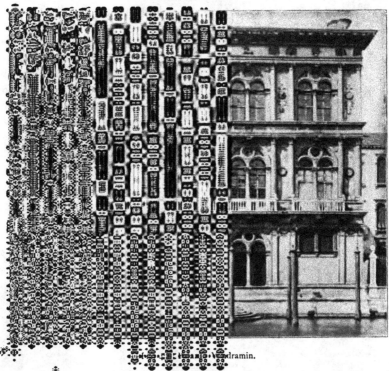

...dramin.

ad retained their local character
because their builders were not
Their very ignorance gave their
this changed with the increasing
style. The ingenuousness vanished.
tian dialect, the late renaissance
ith ever loudening voice the great
subject to exalted principales, so
banausic person was allowed to
ature of the new style, that made
Unlike to Gothic art, it was no
ow Burckhardt's beautiful expres-
f the masses. It was here desirable
ed by the early renaissance; but
purpose was superfluous, if not

from antique Roman fragments, and
us watch over the preservation of these
ed with the preceding period of Gothic
The plan and the separate parts of
by a severe, constructive law; the
the harmony of the impression, the
ere severe laws were in force, but they
could not be circumscribed by strict

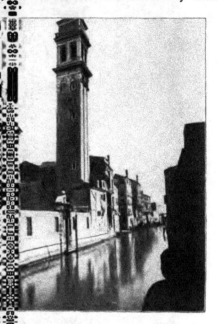

orgio dei Greci.

s on the part of the Italian scribes of

rence. Soon, however, and to a higher
d its claim on general application. As
century, Palladio's works presented
which was not only impersonal, but
matter of fact, found its way over the

ng up in Venice, are, it is true, supremely
ance, but they are no longer like their

be most interested in those,

...ived his training in Bramante's
...ect of the late renaissance in
...aused him generally to place

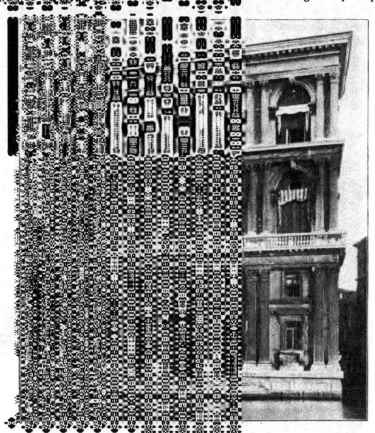

...cation. Thus he has gradually
...of the Republic of St Mark.
...uild a few palaces in Verona
...44) on the Grand Canal, now
...When it was built — about
...lings, and even now, with the

upper storeys, it is the most imposing
... on the Canal.

...eli entered the service of the Republic
...tine *Jacopo Sansovino* came to Venice,
... the puritanic mind of Pope Hadrian VI.
...ready at that time, in 1523, he had
...er he settled there permanently and
...ntment of a *proto de supra*, or chief

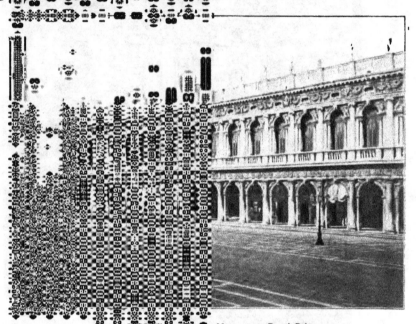

Marco, now Royal Palace.

... governmental buildings of Venice (with
... If Sanmicheli, in all his buildings, had
... Bramantesque architecture, the versatile
...etian leaning towards luxurious, festive
...ame age, he soon made friends, and
...1570 — he occupied a similar leading
...ture of Venice, as Titian did in her
... next generation of Venetian sculptors
...dings have left upon the general picture
...sonality, than of most of his followers.

But unfortunately his artistic character was not on the level of his talent; he sometimes gave himself licence and produced, by the side of immortal work, some careless and mannered things.

Of his churches *San Giorgio dei Greci* is the most notable (fig. 43). The two-storied front leans so much to the style of the Lombardi, as regards the details of the decoration, that the collaboration of a member of that family, of *Santo Lombardo*, has been taken for granted. The interior, a nave terminating in a barrel vault with a central dome, is traversed by an ikonostasis adorned with Byzantine paintings, and is not particularly interesting. For the tedious edifice of *S. Francesco della Vigna* Sansovino can perhaps not be held entirely responsible, in so far as the monk *Francesco di Giorgio*, who had some knowledge of architecture, made some corrections in his plan. The façade was subsequently added by *Palladio*. — Still less important are Sansovino's later churches of *San Martino* and *San Giuliano*. — On the other hand he gained well deserved and immortal fame with the secular government buildings of the *Biblioteca* (fig. 45) and the *Mint* (Zecca) (fig. 46). Both were commenced at the same time, 1536; they stand wall against wall and form the most striking contrast that may well be imagined. In masterly fashion Sansovino knew how to suggest the destination of the buildings in their external shape. With its rude rustic blocks which form the walls and pilasters, with the walled-up arches of its ground floor, this Mint is closed threateningly against any uninvited person who would force his way into its treasure chambers. The splendid arcades of the Library, on the other hand, are opened to all who may wish to congregate under its roof for the purpose of peaceful study. The long extension of the building with its moderate height can in no way be objected to, because, as Burckhardt rightly observes, the whole, as an arcade building, could be allowed to be of indefinite length. The arrangement of the series of arches is incomparably beautiful. On the groundfloor they rest on simple piers with projecting columns, on the top-floor on pairs of fluted columns. Above all there are few buildings in the world, that produce as rich an effect of light and shade. If fault must be found in spite of such great merits, it should be with the crowning parts of the building. The balustrade of the roof is certainly too heavy, the upper frieze perhaps too high, and the garlands too, by which it is decorated, appear far too weighty for the little boys who are burdened with them. Yet it must be confessed, that this very boldness of the relief is of advantage to the effect of light and shade.

By the side of these two masterpieces the *Loggetta* under the ill-fated Campanile could not hold its own as an architectural effort. The enormous attic weighed the portico down into the ground, an impression which was still further intensified by the fact that the lower parts of the groundfloor disappeared

greatest merit of the dainty building
Fabbriche nuove, which Sansovino added
he Rialto bridge, do not deserve special
ned the Grand Canal with some palaces
. This applies particularly to the *Palazzo*
groundfloor and the richly articulated
. 47). More simple is the *Palazzo Manin*
ur arches in the middle of the upper
he entire groundfloor. These palaces of
ished from the older ones already by

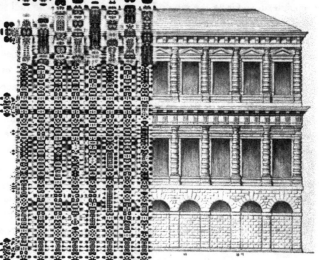

The Zecca.

aissance was loth to agree to the smaller
le for the dainty Venetian Gothic. As
ovino's late period the *scala d'oro* in the
An enormous quantity of plastic and
o an unfavourable and disproportionately
concessions to the ostentatiousness of

Sansovino found in Venice a rival who.
s versatility of talent, but, on the other
architectural gifts and intense seriousness
1518 at Vicenza which was then under
architect, but marks as such the zenith

For his art his name is of
have reproached him with
…mbering, that the originality
…so much in their individual
…their intentions and their

…ds truly brilliant feeling for
…ch complete sway over him,

…rande.

…ot immediately connected with
…mains of Roman buildings had
…d employed their language of
…is unexampled. That such a
…ake no concessions and did
…ly natural. His finest churches
…icenza or elsewhere. He has
…n of his church of San Giorgio
…completion of the picture of
…nd the mark. The site had
…nd the adjoining cloisters were

being built, before Palladio arrived (1565). Considered by themselves his churches are closely related to each other, especially as regards the exterior: one solitary columniation supports the central chief pediment; the aisles with half pediments lean against the central building; the surface of the wall between the columns is relieved by niches. At *San Giorgio* the main porch appears sunk as it were between the high pedestals of the neighbouring columns, nor is it beautiful that the impost-moulding extends above the aisles behind the columns, thus cutting across the whole façade. Similar is the front of *S. Francesco della Vigna*. Both faults have been avoided on the church of the *Redentore* on the Giudecca (fig. 50). The interior too is here most beautiful, though less richly articulated than at San Giorgio; particularly brilliant is the view of the choir which is surrounded by a light gallery. The details of the capitals and mouldings show, as in all Palladio's work, an intentional and dignified simplicity. The coved ceiling on the other hand is almost chilling in its effect. At a later period the type of Palladio's façades is once more faitfully repeated in *S. Pietro di Castello* (by *Smeraldi* who perhaps made use of a design by Palladio). It is significant that Palladio, as far as we know, has not built a single palace in Venice. He evidently could not get reconciled to the restriction of space and to the peculiar Venetian customs.

Only a very small portion of what has been built in Venice after Palladio is worthy of general attention. The fame of the Rialto bridge (1587) is due more to the boldness of its design, than to its beauty. Two rows of shops and three streets extend across the water on a single, bold span. Its builder, *Antonio da Ponte*, had faced the competition of the greatest architects of Italy — of Michelangelo, Vignola, Sansovino and Scamozzi; Palladio, too, had in readiness a beautiful design for a bridge of three arches (fig. 51).

The same da Ponte deserved well for his successful restoration of the Doges' Palace after the fire of 1577; he is also responsible for the impressive rustic architecture of the *Prigioni*, which forms an excellent counterpart to Sansovino's Zecca, surpassing it perhaps as regards the harmony of the general effect (fig. 53). *Alessandro Vittoria* is of more importance as a sculptor, than as an architect (*Palazzo Balbi*, now Guggenheim). *Vincenzo Scamozzi*, the great theorist of later renaissance architecture, produced with his *new Procuratie* a fatiguing replica of Sansovino's Library, which he spoilt by the addition of a second storey. With his *Palazzo Contarini degli Scrigni* on the Grand Canal he varied the type of Sansovino's Palazzo Corner. A strange personality of the later period was *Baldassare Longhena*, the last architect whose numerous and peculiar buildings have helped to a considerable extent to give Venice its present physiognomy. He was an ardent soul with a most extravagant

...e in some showy monument. ...e Frari (fig. 76), which in its ...of skeletons and two dragons. ...ase the developement of the ...cts, as a contrast to the sober

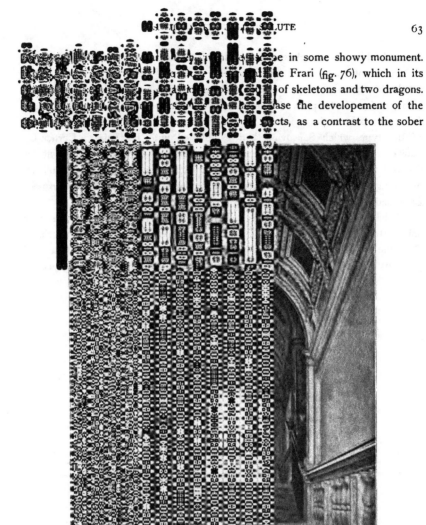

...the Doges' Palace.

...again takes into account the ...ther by the early renaissance ...e of the Bernini and Borromini. ...*lla Salute* is one of the most ...) and cannot by forgotten by ...nal (fig. 54). The picturesque ...tiful cupola which rises from

a wreath of enormous volutes decorated with statues, is of exceeding splendour. One dees not wish to see anything else in this place. That, strictly taken, the back cupola above the choir and the turrets by its sides destroy the homogeneity of the plan, did not interfere with the intentions of Longhena. Among his palaces the enormous *Palazzo Pesaro* marks the richest developement of the type which Sansovino had established with his Palazzo Corner Cà. Similar to it is the *Palazzo Rezzonico-Browning*. Where the means at his disposal were restricted, Longhena had recourse to the manner of the Lombardi by giving life to the walls by means of projecting panels (*Palazzi Giustinian Lolin* and *Mocenigo*).

What else has been created during this period and later by the more unimportant architects, may on the whole be passed over with a good conscience. Only the *Dogana di Mare* by *Giuseppe Belloni* will for all times take its assured place by the side of the Salute as a masterpiece of picturesque perspective.

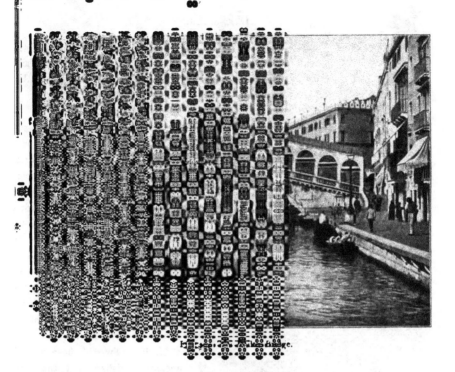

... have not developed to such
... have carried on a separate
... held them gathered in her lap.
... and Sculpture embellished the
... shoots, as miniature painting
... an independent life. With their

... played, than in the neighbouring
... were undoubtedly to be
... The Byzantine artists, the
... decorators, and as such were
... coration, than of a sculpture
... the Venetians really differed
... workmanship was less delicate.
... to be found. A large quantity
... ches and palaces of Venice:

5

..s, and symbolic animals. They clothe
...d the wells and, in Torcello, the choir-
...tte of the South East arch of S^t Mark's,

...he thirteenth century.

as 1233 the Doge Jacopo Tiepolo and
his successor Marino Morosini were
buried in ancient Christian sarco-
phagi (the former by the porch
of S. Giovanni e Paolo and the
latter in the vestibule of S^t Mark's).
The two *porphyry reliefs* with the
embracing kings and queens on
the South side of S^t Mark's are
imported from Byzantium. An
isolated, more important effort in
figural sculpture of that period is
preserved in the columns of the
altar tabernacle in the church of
S^t Mark's. (Two of these are still
ancient Christian, but the other
two copied from them in the
twelfth century.) The narrow relief-
bands which encircle the columns
have, it is true, the appearance of
much enlarged ivory sculptures.

The fourteenth century, which
enriched Venice with the Doges
Palace and with a flourishing
original style of architecture, now
also brought to a head a vitali-
movement originated in Tuscany, where
...ique, had refound an elevated style of
...much the example of Niccolo, but of his
...n Venice. At the beginning of the four-
...worked in the neigbouring Padua, simul-
... Giotto. His grand, realistic style appears
... century sculpture in Venice — in the
...urch devoted to the Saint) of the year
...ing has not attained again to the monu-

of more loving observation
in the cloister of the *Carmine*
er convent of the Carità (1345),
prch of the *Frari*. The briskly

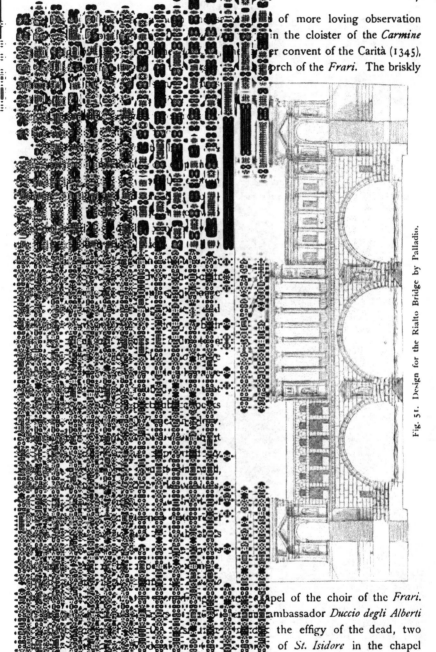

Fig. 51. Design for the Rialto Bridge by Palladio.

apel of the choir of the *Frari*.
mbassador *Duccio degli Alberti*
the effigy of the dead, two
of *St. Isidore* in the chapel

5*

effigy of the departed is particularly
historian of Venice, who had founded
vise in the church of *St Mark* (1354 in
reveals remarkably clearly the Tuscan
d by two angels and bordering the

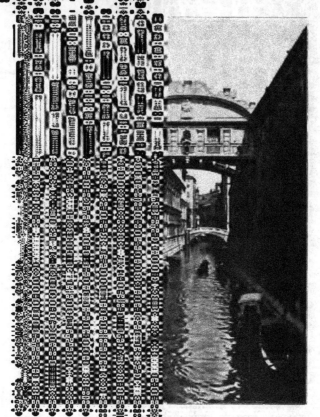

Bridge of Sighs.

r enrichment of the wall-tomb can be
Marco Corner (d. 1367) at *S. Giovanni*
of state; above it, along the wall, is
res of Saints are placed. The opposite
ni (d. 1382) shows the Gothic type in
niche is canopied by a richly sculptured
s in the shape of tabernacles. Altogether

...saic of the Crucified Saviour

...ulpture in Venice is connected
...*egne.* The fact, that we have
...iaeval method of corporative,
...he clumsiness of the attitude
...res appear as the forerunners
...ads and in the softer flow of
...r period is not in Venice. It
...ologna, authenticated as the
...o dalle Massegne. Nearly a

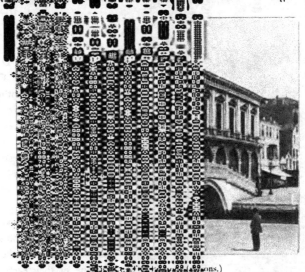

...ons.)

...Apostles were finished, which
...getic in expression than the
...has lately been recognized as
...the South side of the Doges'
...modest wall-tomb of *Jacopo*
...la di Pio V.). It is completely
...tion — the statues of the virtues
...hic tombs of Venice.
...segne are, to mention only the
...of the Doge Antonio, his wife
...); the *altar* in the christening

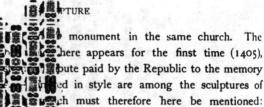

...monument in the same church. The
...here appears for the first time (1405),
...bute paid by the Republic to the memory
...ed in style are among the sculptures of
...ch must therefore here be mentioned:
...rner-sculptures of *Adam and Eve* (fig. 57)

It is again Tuscan influence
that characterizes the period of
transition from the Gothic to
renaissance art in Venetian sculpture. The beautiful *high relief*
of the *Judgement of Solomon*, on
the corner of the Doges' Palace
by the Porta della Carta, is the
work of two Florentines — *Pietro
di Niccolò* da Firenze and *Giovanni
di Martino* da Fiesole (fig. 58).
Not only the carefully considered
composition of these five figures
in such a difficult place, but even
more the nobility of the forms
of the body and of the drapery,
raise this work above everything
that had been produced by the
earlier time of the Massegne.
In one of their earlier sculptures,
the tomb at *S. Giovanni e Paolo*
of the Doge *Tommaso Mocenigo*,
who had died in 1423, the same
artists entered completely into the
spirit of the Venetian tradition, but
...developement. The sarcophagus with its
...on the wall above, were older motifs. But
...e canopy which projects from the midst
...m which the folds of a curtain hang
...omogeneity of an ideal composition is

...ed *Master of the Pellegrini Chapel* at
...of the overdecorated terracotta monument

Chioggia. The tomb, erected
the Buon family, whence arose
an incription — that it is the
wealth of Florentine invention
old Venetian form of a niche-
wever, badly mutilated.) The

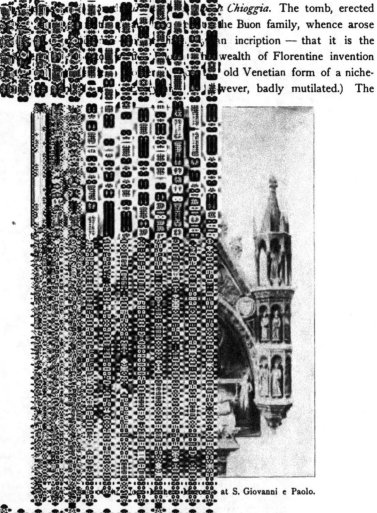

at S. Giovanni e Paolo.

ly puzzled the Italians and has
story of Venetion art, to form
his eyes an inflated German

naissance, who was the moving
r works, *Donatello*, is himself
e of *S^t John the Baptist*, which
re — placed in one of the left

shows the Baptist as an ascetic recluse ... It is remarkable, that the Venetians ... more from the hand of Donatello who ... in their immediate vicinity, in Padua. ... taste. About the same time an able ...o, among other things, has created the

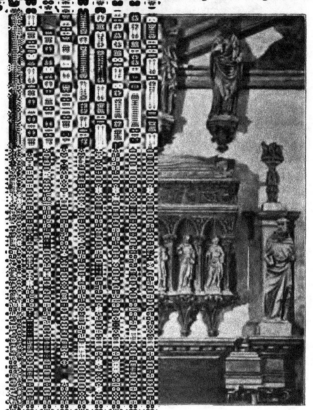

... nio Venier at S. Giovanni e Paolo.

...Isola Bella, was repeatedly occupied in ...chiefly on decorative sculpture (on the ... and the *porch of S. Giovanni and Paolo*). ...f Verona, was given the opportunity of ...he versatile man is already known to ...s' Palace; he was employed in 1475 as ...re of Scutari; but his most important

...ately his activity was suddenly
...with prosecution for extensive

...unquestionably the figures of
...hes on the Torricella of the
...he *Eve*, with the somewhat

...corner of the Doges' Palace.

...compared with her companions
...masterpiece of the first order
...only the value of a traditional
...ge eyes wide open, the first
...the world. The forms of the
...sness of the early renaissance.
...he fault of the model. It was

...at it could be very realistic and yet atese qualities are combined to a highuseo Correr, which has been pronounced — whether rightly or not I can not say to be a work of Rizzo. — His famous tomb of the Doge *Niccolò Tron* at the Frari is the first of the large renaissance tombs of Venice. It is, by the way, at the same time a good instance of the thirst for glory of that period (fig. 65); that is: the artistic splendour was in obverse ratio to the importance of the glorified prince who breathed his last in 1433, after two years of inactive, uneventful government. The construction suggests on the one hand the many stories of the façades in the Lombardi style, and on the other hand, in the row of niches with figures above the sarcophagus, the disposition of the older Gothic tombs of Venice. The most valuable part is the effigy of the Doge who appears again two stories below his sarcophagus, with the air of a "slim", old housefather who steps towards us

...the Virtues compare very unfavourably ...rise with an artist with such a pronounced ...re, as Rizzo.

...n of the artists' names was, that for a ...cesco *Foscari* (d. 1457), which faces the ...d to be a work of Rizzo's. It is however ...e was *Bregno* and who had immigrated

...nd the Tron monuments have
...und the fully developed early
...still wrestled everywhere with
...ediment with its creepers and
...with them we find Corinthian
...cantilever. The female figures

...o at S. Giovanni e Paolo.

...the front of the sarcophagus.
...related to the most important
...*Bartolommeo Buon* whose *Porta*
...Antonio Rizzo. It was robbed
...ime of the French occupation,
...cari kneeling before the lion of
...examples of Buon's sculpture,

...son with that of the masters of the ... on *Sta Maria dell' Orto,* by the altar of ...*tures on the pediment of S*[t] *Mark's* (fig. 16). ...orative, than towards figural sculpture.

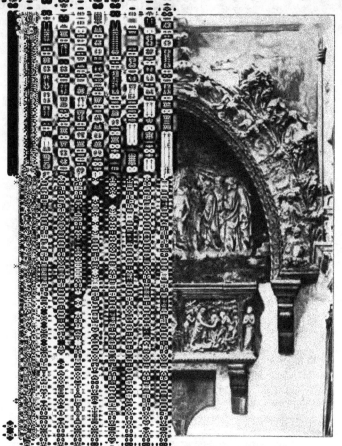

...o Carissimo da Chioggia
(...mb of Beato Pacifico Buon).

...were of importance, in so far as they ...n the plastic art of Venice, the same ...or the fully developed early renaissance ...played an analogous part in Venetian ... let me repeat — of Venetian descent; ...their new surroundings so completely,

...ists of their kind and of their
...native soil a treasure of most
...how to ennoble his style of
...ith which one could here get
...Perhaps his inclination tended
...tues of *S^t Jerome* and *S^t Paul*

Fig. 61. S^t John the Baptist,
wooden statue by Donatello.

...g. 66). The composition is far
... with the sarcophagus of the
...stories. The bed of state, on
...phagus proper. The repetition
...since the modest coffin appears
...re is bestowed upon the orna-
...rs, arches and friezes; on the

avoided to place the personality of the
the spectator. Compared with the Tron
also lifeless. If everything expresses
monument of *Pietro Mocenigo* sends
Here Death has been overcome. As in
ding on his sarcophagus, is carried by

Fig. 63. Eve by Antonio Rizzo.
Doges' Palace.

pened, so as to show the breast-plate.
did, defiant head. Rizzo would probably
but even in this somewhat stiff effigy
avour of introducing as many figures as
ed the receding side portions of the
rk background of which the shapes of

...ately these slender lads are

...ches at the sides and with

...nument of *Jacopo Marcello* at

...of the princely tomb can be

...erected to *Andrea Vendramin*.

...nb memorials, and rightly so.

Antonio Rizzo.

...mutilated and foolishly altered.

...ed than hitherto. Two high

...che. On the sarcophagus the

...who reposes above their head.

...es at both sides. A period,

...removed them and replaced,

...s at the sides of the monument,

...their character. The purely

...ron at S. Maria dei Frari by Antonio Rizzo.

are worked out much more
the case with the Lombardi.
rmony of the whole. A pure
omb (fig. 68).
which are still to be seen

at S. Giovanni e Paolo.

of the earliest that deserves
piero (d. 1462) at *S. Giovanni*
elief of the *Coronation of the*
altar with St *John the Baptist*
of the *Pietà* in the Capella
mbardo. The two small *altars*

rk's, on the other hand, are obviously

mument, which place it above the others

collaboration of a sculptor who, trained

surpassed them by a long way — of

resses itself without difficulty on every

ro Mocenigo at S. Giovanni e Paolo.

ster of the three wonderful *flagstaffs* in

ticulation and decoration of their bronze

right thing so completely, that for all

ple which has been copied in endless

more graceful, than the Lombardi. He

ender, curly-headed youth of somewhat

ned figures on the Vendramin tomb. Two

nude shield-bearers from the same monument have found their way to the Berlin Museum. Of noble beauty are also his bronze figures of the Virtues which surround the sarcophagus of *Cardinal Zen* at *St Mark's*. In Florence a man of this type would perhaps have found a succession of great tasks, which might have helped him to develop into one of the leading masters of his period. In Venice he had to exhaust his best powers on decorative works.

It is significant, that the Venetians would not entrust a great task of monumental sculpture to any of their native masters. For the execution of the monument, which the general Bartolommeo Colleoni had stipulated in his will as a return-gift from the Republic for his fortune, a competition was opened to the leading sculptors of Italy. *Andrea Verrocchio's* design was accepted and the commission given to him. The statue was the last, and at the same time the largest and finest work of the master who counted a Lionardo among his pupils. Never again have horse and horseman been immortalized in art, cast thus completely, as it were, in one mould. It is more than a portrait of the Condottiere Colleoni who for good payment fought the wars of the Republic against Francesco Sforza: it is the type of the warlike hero of an age, when morality counted for nothing, reckless determination and contempt of mankind for everything. The charger prances heavily — one might imagine it passing along a bloody battlefield. In heavy armour and welded, as it were, to his saddle, is seated the horseman with an expression on his face, which can only be described as terrible. Verrocchio has here — notwithstanding the seeming calmness of the attitude — dared a degree of expression which borders close on exaggeration. A little more, and the hero will become a swash-buckler. Only an artist as sensitive, as he was brilliant, could have ventured to go so far. Verrocchio died over the casting. *Allessandro Leopardi* then looked after the final execution. His name can be found on the girth of the horse. His work is also the beautiful socle with its six Corinthian columns and the richly decorated frieze. It appears to many much too high, and, indeed, it would not suffer, if it were shortened by removing the two lowest steps (fig. 70 and 71).

The Colleoni was the last and grandest monument of the early renaissance in Italy. An entirely new era in the developement of Venetian sculpture, as well as architecture, is marked by the advent of the late renaissance. Of course — I hasten to add — the two periods of style do not stand here in such striking contrast, as say in Florence, where since the beginning of the sixteenth century the time of individualising, of dainty and pleasing decoration, was followed by a time of conscious idealising, of joyless grandeur. In Venice the tasks of plastic art had never been taken so seriously. The pronounced predeliction for rich, decorative effects had determined the character of quattrocento sculpture,

of late renaissance sculpture. That this
pearance at the threshold of the new era
acopo Sansovino. If one bears in mind the
e can hardly understand, that their creator

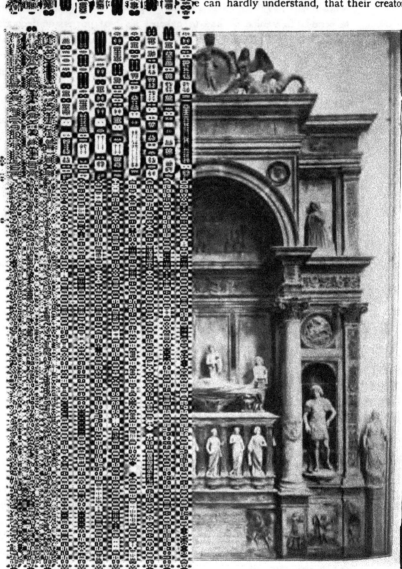

rea Vendramin at S. Giovanni e Paolo.

a Sansovino, and had after-
helangelo. Those two verily
t must be admitted, Jacopo's
and sometimes Michelangelo's

69. Alessandro Leopardi.
of a Flagstaff in the Piazza.

ble light. The four statues looked splendid
nt as regards the flow of lines, although
attitude of the raised left shoulder is
is by no means a faulty design. The
her torch, is distinguished by beautifully

chio's Colleoni Monument.

ner attitude some models by Michelangelo
iefs of the attic are, it is true, lacking
nost effective in their position. In his
nier (d. 1556) at *S. Salvatore* Sansovino

by the fall of the Campanile, but all the fragments

...the early renaissance tombs. ...ly articulated with precious, ...oge is dignified, but without ...tiful "Hope" in the right hand

...o's best works in bronze. He ...r which leads from behind the ...om the corners are supposed ...and of Aretino. The figures ...ellent; but the reliefs of the ...e less successful, overcrowded

... six *reliefs* from the history of S^t Mark ... *statuettes of the four Evangelists* before ... inctly reminiscent of Michelangelo. ... renaissance art had already entered ... hich reaches its zenith in the baroque.

Fig. 73. Jacopo Sansovino. The Genius of Peace.

... fied, as at that time. After they could ... nought that art had no more tasks for ... ully. Quiet beauty satisfied them no ... nger effects by exaggerated movement, ... scles and by gigantic proportions. In ... considered work as unnecessary, and ... The master should also reveal himself

if one hears of the enormous
few decades of a human life
seventeenth century. Rarely,
crificed such sums for art pur-
and ease of production were
the work. Architecture did

Fig. 74. Alessandro Vittoria.
Jerome at S. Maria dei Frari.

sin at *S. Francesco della Vigna.*)
man with flowing beard (statue
e altar at S. Francesco della
ose of the aged Titian (fig. 74).
Zacharia above the porch of
draped statue. Vittoria's por-

; one of the best, his *portrait of himself*, ... most valuable of his other busts have ... are certainly cleverly and effectively ... praise contain a reproach? — An artist, ... has his eye on something better than

... he high altar of S. Giorgio Maggiore.

... *amo Campagna,* a pupil of *Danese Cattaneo,* ... marble relief above the high altar of ... by two angels, is beautiful and noble, ... His fomous chief work, the bronze- ... gio Maggiore, represents God the Father ... by the four Evangelists. With all the ... mething repulsive to our feeling in this ... ses (fig. 75). A good portrait figure of

Campagna's early period is that of the Doge *Leonardo Loredan* (d. 1572) at *S. Giovanni e Paolo*. Better still, and more mature, is the statue of the Doge *Cicogna* at the *Gesuiti*.

Tommaso Lombardo's signature confesses him to be the master of a rather vexatious *Madonna group* at *San Sebastiano* (fig. 77). But why mention further names? Figural sculpture has sunk lower and lower in Venice with the school of Sansovino, never to rise again from the depth. For the tombs of the Doges a vainglorious wall-architecture came finally in use, the sculptures being provided by very indifferent artists. We have already mentioned with the works of Longhena a particularly fantastic monument of this Kind: the *Monumento Pesaro* at the *Frari* (fig. 76). In the other church of the Doges, at *S. Giovanni e Paolo*, is a tomb, if possible of still larger dimensions, on which are seated the Doges Bertuccio and Silvestro *Valier* and the Dogaressa Elisabetta, holding a stately conversation.

Decorative sculpture on a smaller scale, on candelabra and such like works, remains pleasing for a long time yet. The two bronze *wells* in the court of the *Doges' Palace* justly enjoy great fame. The more richly decorated of the two is the one on the North side (by *Niccolò de' Conti*, 1556) (fig. 78), the better articulated-one on the South side (by *Alfonso Alberghetti*, 1559). The finest of the marble well-kerbs of the renaissance (somewhat early in date) adorns the *Campo San Giovanni e Paolo* (fig. 2). Of the candelabra the most famous is probably the one by *Andrea Bresciano* to the left of the high altar of the Salute (1570) (fig. 79). A little later in date (1598) are the two splendid candelabra at San Giorgio Maggiore by *Niccoletto Roccatagliata* (fig. 80). Every traveller will easily discover further examples in the churches of Venice. As late as the middle of the eighteenth century originated as charming an example of bronze-casting, as the *gates of the Loggetta* (by *Antonio Gai*), which have fortunately not suffered much damage by the fall of the Campanile (fig. 81). Thus the survey of Venetian sculpture returns to the sphere from which it had proceeded — to decoration.

rthel. Monumento Pesaro at the Frari.

PAINTING.

enice is beautified, painting has achieved
lacked the necessary space for solving its
and lofty sculpture there was no lack of
on the part of the Venetians. Here, where
was demanded of the arts, sculpture fell
ecoration. Only the art of painting was
in accordance with its very own laws.
more healthily and undisturbed than any-
the very condition which hat interfered
want of a deeper enthusiasm for anti-
ique art, which for a long time had taken

...e in all other parts of Italy, ...of the purely formal beauty ...The whole history of Central ...Lionardo, Raphael and Michel- ...nters remained more unbiassed.

Fig. 77. Tommaso Lombardi.
Madonna at San Sebastian.

...shall understand that the stiff ...yzantine saints weighed heavily ...t. Thus it can be explained, ...bouring town of Padua, where ...iis greatest works (from 1303), ...ept the solitary mosaic of the ...e Doge Morosini at S. Giovanni

shows traces of the Giottesque style.
of *Fra Antonio da Negroponte*, or of
useo *Correr* and at *S. Francesco della*
tters of Byzantine tradition and suffer
aces and overloading with figures and
nous canvases painted with the picture
by *Donato Veneziano*, a kindred spirit
archaeological museum in the Doges'
numental painting was concerned, they

in the Court of the Ducal Palace.

home talent. For the decoration of the
Palace the Umbrian *Gentile da Fabriano*
summoned to Venice. Unfortunately a
were already badly injured.
onnected the liberating developement of
Of the father of the famous brothers
tions to Gentile da Fabriano were those
ements are not clearly made about the
out their paintings suggest such a theory.

ano are attached to a series
Venice, which betray on the
gilded decoration their depen-
, but on the other hand in

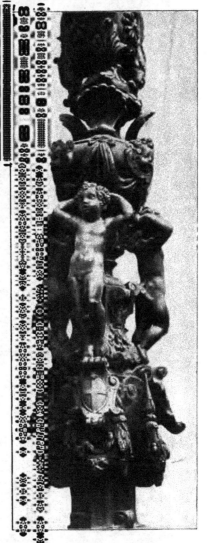

80. Nicolletto Roccatagliata.
in the choir of S. Giorgio maggiore.

...k of Christ, with the Infant in her lap,
... a splendid Venetian garden-court and
... church. One of the painters betrays on
...lling himself *Johannes Alamanus*. Among
...the three polyptichs on the altar of the
...*ia* (with splendid, richly carved frames),
...' *Pantaleone*, deserve attention. Antonio
...ed of sharing his work with an assistant,
...ceased to be his collaborator (about 1450),

...i. Gates of the Loggetta.

...olommeo. We can quite understand this
...her feeble and unpleasing picture which,
...shed by Antonio alone in his later years
...lery of the Lateran in Rome.
...*ommeo*, who sometimes describes himself
...e mentioned as the first self-centred per-
...netian painters. We see in him a marked
...a talent, Manliness is the ruling trait in
...serious men with wide foreheads, strong,
...They are no longer the lifeless dolls of

ponderous shapes. At times
y — as in the altar of St Mark
and lovable. He draws with
ously in all parts, that they.
xample of the Paduan School

oronation of the Virgin. 1440.

n. Of course, he never was
ative power, nor even in taste
enetian painting Bartolommeo
one of the first to renounce the
turn towards oil-painting. The
traveller in many parts, who
he had collected since 1473

7

...xt year Bartolommeo Vivarini made use
...irse as yet, in the manner of tempera
...pictures, the altar-piece of 1464 at the
...shows the Virgin with the slumbering
... Bartolommeo's capacity (fig. 83). His
...y the side of the above-mentioned altar
...the now mutilated altar of St Augustine
...weaker and almost mannered is the

... Altar-piece in the Academy. 1464.

...ar at the *Frari*. Further works from his
...in Venice and in the galleries of Upper
...tray to a marked degree the collaboration

...hers Antonio and Bartolommeo Vivarini,
...dar attention. Unfortunately this most
...enice by two pictures only (St. Jerome
...hree other Saints, at the *Academy*). The
...is in him increased to obstinate hardness.

grim in the expression of the
have an air of exaggerated
by his deep seriousness, and
tempera painting with its pro-
are no masters in old Italian

Baptist. Academy.

in as perfect and fresh a con-

wenty years of his life in Venice,
ian art. For it was here, that
his nearest relations in spirit,
thought. Next to technical

7*

...acterized by a certain hardness of de-
...o and the Virgin of the Ascension at
...n his portraits, of which the *Giovanelli*
...t young man in a red coat). Antonello
...on the other hand he could hardly satisfy
...ature.

...uence of the foreign painters Pisanello
...llo, upon the Venetian artists, were not
...ly a little later the artists' family of the

...onna. Sacristy of the Redentore.

...tance. The competition had become so
...olommeo Vivarini had finally to give it
...r hand a younger member of his family,
...with youthful vigour and, for some time,

...with the inherited methods of his family.
...arly pictures recall Bartolommeo's. But
...s with a new spirit. The very faculty
...ng — that of individualizing his figures —
...t his large Madonna of the year 1480,

at the *Academy!* Here we have before us the first *"santa conversazione"* of
Venetian art. The Saints are not parading side by side in stiff dignity, they
hold intercourse and converse with each other. Mary, though she be seated
on her throne, dressed in a cloak of cloth-of-gold, still remains the humble
handmaiden of the Lord. She seems to have addressed her speech to St Anthony,
whose eyes are modestly directed towards her. Joachim, lifting his hat in
salutation, offers a dove. And what splendid character figures are grouped
together on the right! — the visionary St Francis and the severe, ascetic
greybeard St Bonaventura. Alvise has a predilection for showing us slender,
meagre men who, as a contrast to Bartolommeo's phlegm, are sometimes over-
flowing with nervous life. This applies particularly to the single figures of
St Clara and of St John the Baptist who, with an animated gesture of his
hand, seems to be preparing a sermon in the desert (fig. 84). The body of
St Sebastian is certainly schematic and somewhat poorly modelled, but does
not his mouth appear to breathe? — All these pictures are at the *Academy.*
Alvise did not shrink from entering the lists with the celebrated pair of the Bellini
brothers. In a letter to the Signory he begged urgently to be employed on the
paintings for the hall of the Great Council, which were to replace the ruined
pictures by Pisanello and Gentile da Fabriano. His request was granted. We
should like to know how his pictures looked by the side of the Bellini's, but
they have all perished in the fire of 1577. Against his will he has probably
been influenced in some ways by his rival Giovanni Bellini. We feel inclined
to think so, if we look at the calm, lovely Madonna in the sacristy of the
Redentore, which is undoubtedly the most graceful work of Alvise's later years
(fig. 85). (A faint echo of it is in the Madonna at *S. Giovanni in Bragora,*
in which church there is also a Resurrection of Christ by Alvise, from the
year 1498.) The last and at the same time one of the greatest works of the
master is the St Ambrose altarpiece in the Cappella Milanesi at the *Frari,*
a dignified picture of sacred splendour. St Ambrose is seated in the midst
of a festive assembly of Saints, on a throne in a wonderfully painted, pillared
hall. As Alvise died during the execution, the panel was finished by his pupil
Basaiti.

His feeling for individual life and his faculty of depicting marked characters
entitle Alvise Vivarini to a high rank among the artists of his time. Yet the
hardness of his technique makes him appear rather as the last representative
of an older developement of art, than as the forerunner of a new art. This
roll has been acceded by Providence to the members of the Bellini family.
The greatest among them, *Giovanni Bellini,* had, during the time of youth in
his ninety years' life, witnessed the first manifestations of independence in
Venetian painting, but could only look upon the bright sun of the late renais-

bered. It is true, like Moses of yore,

mised land, without being able to set

her with his brother, could claim for

ducted the race of Venetian artists to

ch. They · were helped · in · it · by · the

Mahomet II. Layard Gallery. Venice.

happens, that we can find nearly· all

enetian painting in the works of the two

inted out, that during the middle-ages

d by the space which it was intended

ed for preference was the technique of

d never properly flourish in Venice —

the Republic. Perhaps it was feared,

that the saline exhalations of the lagoon would spoil the colours on the plaster-wall. And that these fears were well founded, is proved by the fate of the wall-paintings in the hall of the Great Council at the Doges' Palace, and later of the frescoes by Titian and Giorgione on the Fondaco dei Tedeschi, which faded already after a few decades. What Venice had thus to dispense with in fresco-painting, proved to be beneficial to the painting of easel-pictures. The painters of Venice, who could only devote themselves to this branch, spent far more care upon the technique of easel-painting, than, say the Florentines, whose highest task always remained fresco-painting. The best-preserved, old tempera pictures of Italy are Venetian, and it is not mere chance, that the technique of oil-painting was practiced first in Venice, before all other towns of Italy. It is clear, that such fostering of the easel-picture was bound to be the best basis for the liberation of the picture from the surrounding setting.

And in yet another direction Venice became important for the developement of modern painting in Italy: in the expansion of subject-matter. If already in the middle-ages all higher manifestations of art had been in the service of the Church, even as late as during the renaissance period the Church claimed for itself the best efforts of painting. Only in Venice the idea of secular government was so active and strong, that the State could rival the Church in her capacity as promotor of culture. Nowhere, as much as here, had the arts to glorify the power of the State, together with the sanctity of Heaven. Thus the artists were confronted with totally different tasks. The paintings at the Doges' Palace were to illustrate the history of the Republic just as the church-paintings illustrated biblical and legendary history. Unfortunately these older paintings of the Doges' Palace have not come down to us, but we may consider as a compensation for their loss the pictures with which the confraternities, or *scuole*, as they were called in Venice, had the halls of their meeting-houses decorated. Of course, there was no question here of glorifying political or war-like deeds; nevertheless the results were, on the surface, pictures of very similar character, for the Venetians loved to see the adventures of their patron-saints pictorially described in the garb of their time. The spectacles, in which they rejoiced most, were the splendid pageants which passed across the Piazza on church-festivals or on days of honour of the Republic. In long procession was unfolded all the splendour of silken robes of state, to which the wondrous buildings of the church of St Mark and of the Doges' Palace supplied the most beautiful setting. Wherever it was possible, such spectacles were interwoven with the description of the legend, whether it concerned the finding or the procession of the splinter of the holy cross, or the adventures of St. Ursula or of St George. It is obvious, that such a manner of representation was not far removed from genre-painting.

...eir own time was also reflected upon
...e looked for and painted on the soil
...youth of the people, St Jerome as a
...Virgin as a happy and healty young
...gious view may object to such a spirit
...ntly heretic, to see in this very spirit

...en the leaders in the direction indicated
...heir father *Jacopo* in Venice from the
...(Capella San Tarasio) and from his
...from his sketch-books in London and

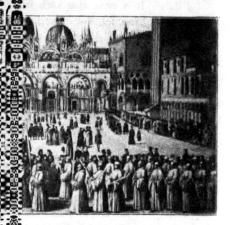

...the relic of the Cross in the Piazza. Academy.

...ry estimable master of his period, who
...tive and had studied antique sculpture,
...roundings. That in his early days he
...o, has already been mentioned. Later
...o Mantegna who became his son-in-law.
...left particularly to his elder son *Gentile*
...of Venetian genre-painting. To judge
...renowned "knight" Gentile, which have
...ost happy in depicting a portait or a
...felt uncomfortable with problems of
...es of Saints, St Mark, St Jerome and
...*k's*), are clumsy and heavy. Also in
...zo Giustiniani at the *Academy* the two

Fig. 88. Giovanni Bellini. Madonna with Magdalen and Catherine (about 1490). Academy.

ideal figures of angels are the weakest part; on the other hand Gentile felt more at ease with the thin character head of the Saint. He was honoured with a commission to paint for the Turkish court at Constantinople some pictures which the redoubted Sultan Mahomet II. desired to have executed by an able, occidental painter. A precious fruit of this sojourn in the East is the portrait of the Sultan, which is now in *Lady Layard's gallery* (fig. 86). Gentile's maturest and most important works are, however, the paintings which he had to execute for the *Scuola San Giovanni Evangelista* (now at the *Academy*). They glorify the miracles of the relic of the cross, which was preserved at San Lorenzo. One of the pictures, the healing of Pietro di Lodovico, has fared so badly at the hands of the restorer, that it can scarcely any longer be enjoyed as a work of Gentile. The other two pictures, on the other hand, — the Procession on the Piazza and the miraculous finding of the splinter of the cross which had fallen into the canal — show us Gentile from his best side. In the procession the accessories already are of interest: the shape of the Piazza about 1500, and St Mark's in the glory of its olds mosaics (fig. 87). But what deserves far more to be appreciated, is the delightful picture of Venetian public life, which is here unrolled before our eyes: the crowds of apathetic looking monks, the slender street-loungers in their tight, multicoloured costumes, the splendid ladies in the retinue of the Queen of Cyprus, the gondoliers and street-urchins and beggers.

The brothers Bellini completed each other, and that was perhaps the reason for the harmony in which they lived side by side without interfering with each other's concerns. Formerly the saying obtained, that Gentile had been more of a theorist, Giovanni more of a practician in his art. I must however confess to being unable to find a natural explanation for such descriptions. It seems to me rather, that Gentile, as the painter of reality, forms a certain contrast to Giovanni who has developed a high style of his art on ideal subjects. *Giovanni Bellini* reveals himself as a stylist in the earliest of his pictures already, that are known to us. But whilst he here devoted his attention principally to form which, after the example of the Paduans, he endeavoured to ennoble to severe purity, he developed towards the end of his life more and more clearly into a stylist of colour and of light. But he has newer rendered homage to the one or the other principle exclusively, for his distinction lay in the happy harmony of his schemes. In each of his pictures he seems to have achieved just what he wanted. We rever notice in his work that unevenness which stigmatizes many a great production of Teutonic art as the result of a high, unsatisfied aspiration. Giovanni Bellini cannot move us even with his greatest creations, but he gives us that refreshing pleasure which is disseminated by health in conjunction with beauty.

...ed to emulate his great son-
...res of the Transfiguration of
... angels, at the *Museo Correr*;
...ala dei tre Capi); and three
...portant of which shows the

...roned. Academy.

adoring the Infant who is slumbering
this period, a Madonna surrounded by
aolo, together with one of Titian's finest
Antonello da Messina, who settled in
ificative for Bellini's further developement

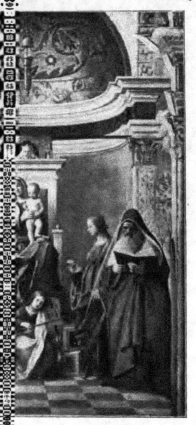

adonna with Saints. San Zaccaria.

light. One of the first of Venetian oil
ur with very effective, warm lighting, is
St Catharine and Magdalen (*Academy*
he same period is the spendid altarpiece
enthroned in a niche, with six Saints at
king angels at the foot of the throne turn
ed concert (fig. 89). Bellini had a distinct

leaning towards this pretty motif in his Madonna pictures, and was imitated therein by Dürer who came in touch with the aged master in Venice in 1506. The Madonna triptych on the altar of the sacristy at the *Frari* bears the date 1488. This beautiful picture has rightly received more admiration than any other of Giambellino's creations. Already its excellent preservation in the splendid carved frame contributes considerably to its effect. But then it is more particularly the simplicity of the arrangement, that intensifies the impression. In a narrow niche thrones the most beautiful of Madonnas, with the Infant Saviour in her lap; the panels at both sides show two pairs of serious Saints in quiet attitudes. The dignity of the general appearance, which is only tempered by the charming little angels with their musical instruments, has never been attained again by Bellini. In this very respect the Madonna at *S. Pietro in Murano* with the Doge Barbarigo in adoration compares unfavourably, how ever valuable it may otherwise be, particularly as regards the landscape background.

How Bellini changed his style in his mature age, is demonstrated by the altarpiece at *San Zaccaria* — the Virgin enthroned, between SS. Peter, Catharine, Lucia and Jerome (1505). Far less stress is here laid upon ideal beauty of form, than on a soft and deep effect of light. The whole canvas is bathed in the golden reflections of sunlight. For larger works the octagenarian master henceforth made use of the help of his pupils, as is revealed by the Madonna picture at *S. Francesco della Vigna* (much restored), and by the splendid altarpiece of St Jerome at *San Giovanni e Crisostomo*. The last-named picture marks, by the way, a further and final advance in the direction of a free and entirely pictorial arrangement, although probably little more than the general disposition is due to Bellini. One would like to think, that at least the heads of the Saints are the work of the aged master's own hands. Wonderfully expressed is the dreamy longing in the eyes of St Christopher, and the gentle melancholy in the features of St Augustine. Bellini has, of course, sometimes repeated his motifs. The attitude of the Infant Christ on the picture at S. Francesco is identical with that on the Murano altarpiece. The *Academy* possesses two versions of a Madonna and Child in half figures, one of which — the less successful one — has the additional figures of St Paul and St George; the other, with the Virgin standing in front of a green curtain, is one of the most beautiful and dignified Madonnas ever painted by Bellini.

One can hardly get acquainted in Venice with Bellini as a portrait-painter, but certainly as a landscapist. In this, too, lies to a certain extent his historical importance for the succeeding generations. One need only see what delicate and charming landscape motifs he has introduced into the five allegorical pictures at the *Academy!* (The puzzling representations were probably full of

destination of a piece of furniture which

...inting hastened as much as possible to comparison with the other local schools

Under the auspices of the last
... oung artists pressed forward,
... ients of the first order, but a
... nited efforts to raise Venice in
... e first rank among the centres

... am. Academy.

...se artists according to schools,
... y direction, and an artist who
... all he knew, expressly called

... whole crowd is unquestionably
... er of the life of his time, and
... e Bellini. By birth he was most

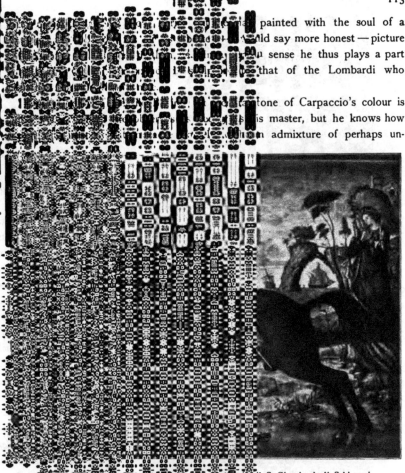

painted with the soul of a
ld say more honest — picture
sense he thus plays a part
that of the Lombardi who

tone of Carpaccio's colour is
is master, but he knows how
n admixture of perhaps un-

li S. Giorgio degli Schiavoni.

dog that watches St Jerome
Sometimes this humour is
possible, still further removed
Carpaccio depicts the fright-
th such sureness of aim; he
rm-eaten bones and putrifying
r (fig. 94). What fancy again
tures! His architecture is no
the latter depicts plainly and
the Grand Canal, Carpaccio

8

...nd façades in the most genuine style of the ...o existence, except on his canvas. With all ... of whom has never seen again grown up in ...Ursula and the study of St Jerome are filled with a sense of comfort, with which we would not credit any Italian. The eye discovers a hundred trifles, in which the painter has taken a keen and loving interest, without losing sight of the homogeneous general effect.

Armed with such talents, Carpaccio appears to us pre-destined to become the master of agreeable, broad narration, and as such he was evidently appreciated already by his con-temporaries who repeatedly entrusted to him the task of depicting for their *scuole* the legends of the Saints in serial form. Two of these series have remained in Venice preserved in their completeness: the nine pictures of the legend of St Ur-sula — now at the *Academy* — and the ten pictures devoted to various Saints, in the *Scuola di San Giorgio degli Schiavoni*. From the Scuola di San Gio-vanni Evangelista, where Gentile Bellini and his school had been employed for preference, Car-

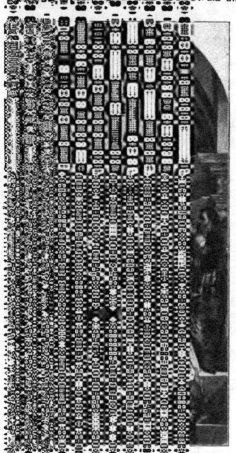

Academy.

...he Patriarch of Grado has come down to us ...he legend of St Ursula were the first to be ...from the dates upon them, completed during ...excellent among them are, without much ...wo scenes in which the English ambassadors ...Maurus (fig. 93). Far less happy than in the

Cross of the Patriach of Grado.
...ity of his talent in the charm-
...hiavoni. Do not shirk the
...s in the poor light of the low
...ng the Dragon is inimitable.

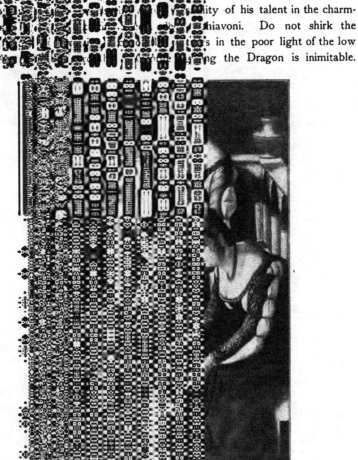

Museo Correr.

...pageantry is presented by the
...resting night-landscape by the
...we enjoy the most amiable
...writing and of the frightened
...pictures of Venetian life are
...who pass away their time

...n passionate movement, as from idealistic
...when needed, to the noble gravity of the
...by his beautiful Presentation in the Temple

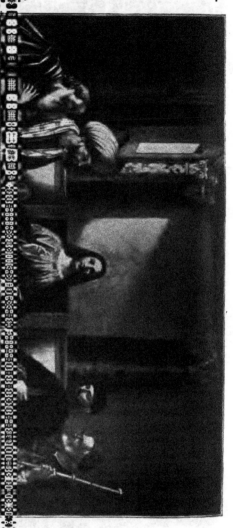

...re is deservedly one of the most popular
...s only fair to admit, that its popularity is
...y-angels on the steps below the platform,
the Virgin and St Simeon. The altarpiece

...maus, which has been ascribed ...h, perhaps to *Rocco Marconi's*

...rtists of the third rank, belong ...*Benedetto Diana*. The pictures ...i San Giovanni Evangelista do not ...llaborators Carpaccio or Gentile. ...be recognized by the excessively

...ith Saints. Academy.

...but also of his architecture (the ...the Madonna and Child at the ...ger and more variegated, bores ...n figures with their stiff, course ...the Academy; his best pictures ...ts at San Giovanni Crisostomo.) ...above these two, if the Madonna ...(Academy, cat. 86) were really his ...th its tender, silvery tone is so ...of which — a Madonna with four

Saints (at the *Academy*) bears his full name, that the attribution appears, to say the least, doubtful (fig. 98). — I may be permitted at this point to put in a kind word for the worthy *Marco Marziale*, who has probably been so badly spoken of, chiefly because he fits so ill into the frame of his Venetian surroundings. His was a course nature, which was simply incapable of idealistic representation. In his Madonna picture at the Lochis-Carrara gallery in Bergamo he tried rather clumsily to borrow something of Umbrian loveliness. On the other hand he was an industrious and clear-sighted observer of nature. If one examines his Christ at Emmaus, at the *Academy* (fig. 99), and his Circumcision of Christ, at the Conservatorio dei Penitenti at *San Giobbe*, for what they contain in the way of characteristic portraiture, one cannot but admit, that he deserves full esteem. Dürer's presence in Venice may most likely have helped to form his style, for we gladly believe, that he felt attracted towards the great Northern master, in whom he must have found a kindred spirit.

The most important of those who followed in the footsteps of Alvise Vivarini, was Giovanni Battista, called *Cima* of Conegliano (1460—1517). Cima achieved all, that could be achieved by fair talent and good sense of colour in conjunction with honest endeavour. The qualities which all his pictures have in common, are artistic seriousness, uniform carefulness in the work, a manly dignity of representation. Wherever we meet Cima, he is sympathetic, but falls short of stirring up enthusiasm. He brought with him from his native soil on the slopes of the Alps an ever-green freshness. In looking at his pictures, the background of which he loves to border with a blue Alpine chain, one could almost imagine to be breathing the cool air of the mountains. For, brilliant and deep though his colours may be — no other Venetian has surpassed him in this respect —, it would nevertheless be very wrong to speak of a glow of colour in Cima's work. His general tone is rather cold, than warm. Cima seems to have developed slowly. Only unwillingly he abandons the technique of tempera for that of oil-painting which he treats with metallic hardness. One of his favourite figures is St John the Baptist whom he represents splendidly as a sun-burnt ascete with dense, black, curly hair and a dreamy, abstract gaze. Thus he stands, surrounded by four Saints, and looking heavenwards with the air of a prophet, in the principal picture of Cima's early period, the altarpiece at *Sta. Maria dell' Orto*, of 1489. Here the forms, and particularly the treatment of the draperies, are still of exaggerated, scrupulous sharpness. On the other hand Cima's art appears perfectly mature in the altar-picture of the Baptism of Christ at *San Giovanni in Bragora* (with rich landscape motifs), which is only a few years later in date. To the same period belong the Pietà at the *Academy* and the Adoration of the Infant Saviour at the *Carmine*. His most charming picture in Venice, in which he approaches

young Tobias who, chatting
demy) (fig. 100). As represen-
ost beautiful. The three figures
pine landscape are monumental
Madonna between the Baptist
nna enthroned and surrounded
mbellini. The two little music-
ious Cima in the last named

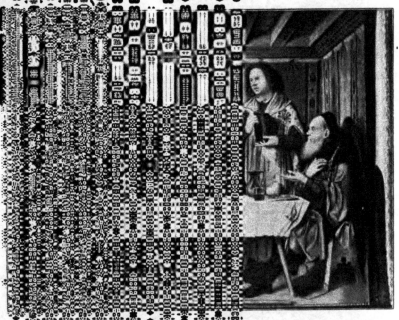

maus. Academy.

with Bellini's as regards love-
llery (both pictures are at the
's brush has unfortunately been
and Magdalen at the Louvre
er steadily continued his deve-
so that he could finally venture
naissance. —
training under Alvise Vivarini,
dent, and even less in character.
e altarpiece of St Ambrose at

...and not exactly very happily — the two
...ian and Jerome). All that he retained
...elling of Alvise's school, was a certain
...elling was much softer, sometimes almost
...is characteristic: he knows how to place
...ad of drawing them up before a land-

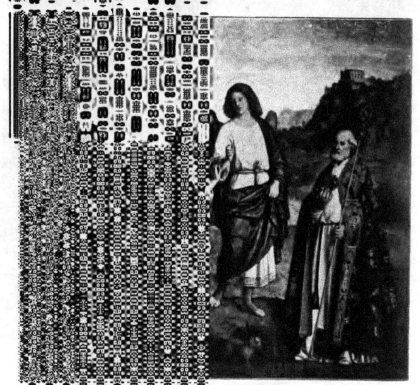

. Tobias and the Angel. Academy.

...his fellow-workers. He understands ex-
...but the barrenness of the vegetation in
...shrubs are avoided as much as possible,
...ok of dry brooms. Of his early period
...ure with the kneeling donor at the *Museo*
...els at the *Academy* (fig. 102). The same
...e in the latter work, appears again in the
...no in looking towards the spectator from

the left of the scene on the Mount of Olives (at the *Academy*) (fig. 103). It is therefore probable, that the picture dates from the same period. One of the last of those paintings by Basaiti, which still betray Alvise's influence, is probably the Calling of the Children of Zebedee, at the *Academy* (with beautiful landscape in evening light). Soon after, he turned towards the victorious direction of Giovanni Bellini. Witness Basaiti's large Ascension of the Virgin at *S. Pietro Martire* in *Murano*. His finest and maturest work, the authorship of which has been denied to him without reason, is the superb St Sebastian in the Sacristy of the *Salute* (fig. 104). In his two late pictures at *S. Pietro di Castello* (the St George and the Dragon and St Peter enthroned) he approaches the manner of Carpaccio.

One cannot take leave of the school of Alvise Vivarini, without alluding to the two greatest artists that have proceeded from it, although the activity of both of them in Venice was only transitory and has left but few traces: *Bartolommeo Montagna* and *Lorenzo Lotto*. The former was still a serious son of the quattrocento, the latter one of the most variable among the great painters of the late renaissance. The dignified character of Montagna's art is revealed in the two paintings by his hand in the possession of the Venice *Academy:* the Christ between SS. Roch and Sebastian, and the Madonna enthroned between SS. Sebastian and Jerome (fig. 105). The last picture in particular clearly bears witness to the approach to Mantegna. The St Sebastian is one of the few embodiments of this Saint in Venice, in which a noble expression of pain has been achieved. By its side St Jerome appears most dignified, but of melancholy seriousness. If in Montagna the whole outward severity of the Vivarini is still preserved, Lotto appears as the master of colour and of a vivacity increased to nervosity. It is just in this last respect that he may at one time have felt related to his first teacher Alvise Vivarini. In his means of pictorial expression, it is true, he soon shook of the teaching of the Vivarini and proceeded with the whole freedom of the mature art of the late renaissance. His earliest picture in Venice — the St Nicholas of Bari enthroned above clouds, with St Lucia and St John the Baptist — was painted by Lotto in 1529 at the zenith of his life. That this splendid piece of colouring with its beautiful landscape is so badly protected, on one of the side-altars of the *Carmine*, exposed to the greasy vapour and smoke of the candles, is truly lamentable. The altarpiece dedicated to St Anthony, which Lotto executed in 1542 for *S. Giovanni* e Paolo, is over-flowing with pulsating life (fig. 106). The amiable old Saint is enthroned on a raised seat and unfolds a petition; angels and cherubs are swarming round him and seem to recommend to him the poor people who wait below for the benefits he is about to bestow. Everything is strongly felt: the crowd who joyfully receive the alms or pressingly hand up the petitions, the two ecclesiastics

...oney, and the good Saint who benevolently

...ferior talents among the older generation ...cenzo *Catena* has never entirely lost the ...which disfigures his early pictures; the ...er turns in him into a general *blonde* key of washed-out tones. Among his early pictures are a Madonne at *S. Trovaso*, and the votive picture of Leonardo Loredan in the *Doges' Palace*. (St Mark commends the Doge to the Madonna enthroned, at whose left stands the Baptist.) One of his maturest works is the altarpiece of St Christina at *Sta Maria Mater Domini*. The *blonde* key of colour is also characteristic for *Bissolo* who, otherwise, possessed perhaps a more pronounced sense of beauty than Catena, but on the other hand was much weaker still in his modelling. His figures, with their flabby limbs and completely inexpressive, round faces, are rarely attractive and sometimes absolutely repulsive. At the *Academy* can be found several pictures from his brush: a Coronation of St Catherine, a Pre-...nnas, the best of which is undoubtedly the ...b in the right hand corner (fig. 107). If ...nes mistaken for their master Giambellino, ...th *Niccolò Rondinelli*. In his case such a ...only because in the pictures of his early ...g all the master's pupils, but also because ...on his own paintings — most probably ...for master who thus satisfied with studio-

...unbelieving.

The *Museo Correr* possesses
...*ntino* near the Fenice a Holy
...ks by Giovanni Bellini.

...of Bellini, *Andrea Previtali*
...he has in recent times been
...s deserve a very high position.
...ves with hunting for faults of
...with Previtali such faults are
...he cause of it is, that Previtali
...or the rendering of which he
...has learnt a few things from

...r. Academy.

The sacristy of *San Giobbe*
...h, the sacristy of the *Redentore*

...years, when three young artists
...rtists destined in the future to
...hole civilized world: *Giorgione*,
...ames signify the zenith of the
...onality determined the particular
...eneration, was Giorgione. He
...ay from that of the Florentine
...plied with the laws of artistic
...y their time, *Giorgione's* sole
...ermost ego, without taking into

... and Roman painting solved the highest ... ration of a given space; Giorgione finally ... unding space. Which deed has been of ... easily be decided.

... stricted to the space of thirty-two years ... pictures that have been acknowledged by

... st in the Garden. Academy.

... uestionable property. But these few enable ... ll which Giorgione exercised over his con- ... a word, the spell of youth — not youth, ... conquer it, but youth, that ponders in ... ream of beauty and happiness, in which it ... has painted, his large Madonna, his rustic

the Child Moses, — everything
We forget to ask, why these
speak or keep silence; we only
re everything is so wonderful,
uld fain believe Vasari, when
cellent singer and lute player.

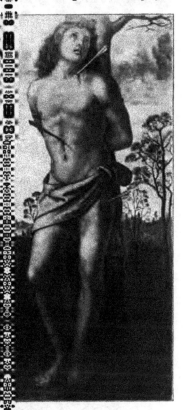

Fig. 104. Basaiti. St Sebastian.
S. Maria della Salute. Sacristy.

se masses of clouds which rise
down. A few years ago the
high degree of probability to
tius. King Adrastus encounters
ruler of Nemea. Whether this
esthetic appreciation of the

The picture has always been admired,
mystery. For that, which needs no
ntelligible, is the mood — that of tender,
embodied in the attitude and expression
he landscape, the green wilderness with
sing thunderstorm (fig. 108).

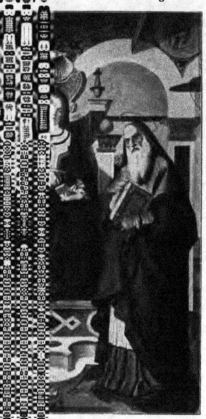

een SS. Sebastian and Jerome. Academy.

gione: that he represents his human beings
ows equally well how to give soul to the
picture of Christ bearing the Cross (at
bright light on the chief figure and the
as effective, as in the few half figures the
of the Redeemer and the brutality of his

intense expression of pain, is
cture already it bady injured,
rsuit of Daphne by Apollo in the
9). The comprehension of the
old representation — as it apears
ground and middle-distance. In

S. Giovanni e Paolo.

admire the grace and ease of the
which we gather of Georgione's
have come down to us, it is not
of wall decoration. His dreamy
we need not mourn over the loss
as much, as over that of many

...ly struck by the unintelligibility of these

... had in Venice, compelled the painters ...would reap applause. Even the aged ...harm, as is proved by his altarpiece of ...p. Even as differently disposed a nature ...que, and that to such a degree, that for ...sed with those of his model. And yet, ...en the two! If Giorgione's ideals were

...nna and Saints. Academy.

...Palma could grasp his with his hands. ...of Venice. What inspired him was the ...with their blooming bodies, with hair in ...risoner, and with the rustling splendour ...e nude, his brush was not led so much by ...of the human body, as by his delight in ...ttle is known of Palma's life; he must be ...made difficult in Venice, for, as in the case ...searched for outside the town, far away ...n Venice has preserved at least three ...brush: besides two paintings of smaller

on of the Virgin) the splendid
helle. The arrangement alone
the three chief figures of the
ch is greatly intensified by the
by the deep, glowing colour.

c. Palazzo Giovanelli.

of such powerful effect. Yet
h on this painting, as on the
he beautiful Saint who stands in
by the frame, may pass for a
personification of the ideal of
Venice. The slightly reclining

something imposing, an impression which
...red drapery which flows around her body.
...ace. The hands are remarkably graceful.
..., that has always disturbed the writer
...the curve of the crown which ought to
...head.) Very unjustly the S^t Barbara has
...e of the remaining parts of the altarpiece,
...h looking at. The Pietà above the central
...g beauty, the S^t Antony most dignified,
...figures of a youth, that can be seen any-

...d Daphne. Seminario Patriarcale.

...one and the great popularity of Palma
...contemporaries — and of posterity —
...on *Titian*. His name signifies, according
...ievement of Venetian art. His star really
...ne. Since then Titian developed slowly,
...ly healthy, harmoniously gifted nature,
...ge could rot affect his delightful gifts,
...ther great man, with yet a new faculty:
...ll the technical means of his art. The
...most advanced age, are the most valuable
...ies. Titian is remarkable as a man. If
...ssunta, what fables would have gained
...n of his character! But during the century
...into touch with the historical personages

ublic life, that we gain a better
ost of the great artists of his
ameless artist's nature, living
n motives. Titian also knew
he had thus acquired, he would
s boon-companion, was Pietro
urse with such a man, who, it
as the wittiest writer of Italy,
at the bottom of his heart was
ersonified. Nevertheless Titian
lose himself in such campany.
t precious part of his nature

Fig. 111. Palma Vecchio. St Sebastian.

9*

n's men and women, with all their won-
...is inclined to believe, that the master has
only just depicted
them exactly as they
once bestrode the
soil of Venice. This
applies particularly
to his most idealistic
figures, like the Christ
in the picture of
the Tribute-money.

Titian's peculiar
greatness consists in
the fact, that he
renders nature with
apparent unpretend-
ingness, and yet pos-
sesses to the highest
degree that "har-
mony which flows
forth from the bosom
and returns to the
heart, embracing the
whole world". Each
of his human figures
contains no less fan-
tasy, than the tremen-
dous men and women
of Michelangelo. His
gift of idealizing can
be recognized first in
his colour which is
incomparably sunnier
than that of any other
Venetian painter, but
his idealizing is by
no means restricted
to his colouring.

Venice still pos-
sesses Titian's earliest

Virgin. Academy.

...ture has gone astray, she also ...of his best period. From his ...e was under the influence of

...nts. S. Maria della Salute. Sacristy.

Giorgione, we have, in the upper storey of the *Scuola di San Rocco,* the Christ as the Man of Sorrows; in the sacristy of the *Salute,* the St Mark enthroned between four Saints (to the left SS. Cosmas and Damian, to the right SS. Roch and Sebastian) (fig. 113); at *S. Marcuola* the Infant Saviour between SS. Catherine and Andrew. The *Academy* guards as its greatest treasure the Ascension of the Virgin, known to the whole world simply as the Assunta. This picture, which Titian has painted (for the high altar of the Frari) in 1518, in his maturity, is nevertheless filled with the fire of youth. It is perhaps the noblest pictorial expression of exaltation that the world possesses. Everything in filled with rushing life. The tomb of the Virgin is empty. The disciples, who a moment before were mourning around it, see her, whom they had believed dead, ascend towards her heavenly kingdom. They crowd and press together, as though they were endeavouring to follow her with rapturous expressions and outstretched arms. She, however, lightly floats upwards, impelled by her own force, as though it could not be otherwise, and surrounded by swarms of the loveliest, dark-eyed little angels. All earthly suffering has left her; her countenance breathes the bliss of Paradise. Thus she looks up to the beloved Father, Who gently floats down towards her, with spread arms, to receive her. To see the picture in pure delight. It is doubly touching, because we see the indescribable presented with unheard-of truth to nature. An immense art is here hidden. The powerful bodies of the apostles, in their relation to the smaller, higher figures, make the space appear larger, than it actually is. Their compact mass is articulated more by colour and light, than by line. The bright circle of light around the Madonna, into which the figure of God the Father seems dipped, produces a most beautiful effect (fig. 112).

Not long after the completion of the Assunta, Titian began his work upon another large altarpiece which was destined for the chapel of the Pesaro family at the same church of the *Frari.* It was only placed in position after the lapse of seven years, in 1526. It marks again a culminating-point in Titian's life-work and in Venetian art. For with it was pronounced the final word in the representation of the religious ceremonial-picture. The kneeling members of the Pesaro family are conceived quite simply in the sense of the quattrocento. But above them is a beautifully composed group in the shape of a pyramid culminating with the heads of Mary and of the Infant Saviour in her lap. The manner in which the shafts of two lofty columns are arranged one behind the other above the figures, became a model for the later art of the eighteenth century. By this simple device the effect of space is very considerably heightened (fig. 114). Of Titian's portraiture, of which this magnificent altarpiece contains such fine examples, the most important achievements must by searched outside Venice. At the *Academy* we only find one of his portraits — that of the

wealthy Jacopo Soranzo, a thin, aristocratic looking man, dressed in the purple robe of the Procurators.

It is ever to be regretted, that the Capella del Rosario at *S. Giovanni e Paolo* was not better guarded on the 16ᵗʰ of August 1867. For on this day, and in that chapel, was burnt, together with one of the finest paintings of Giovanni Bellini, a picture by Titian, which, like no other, would have helped to complete the great qualities of the Assunta and of the Pala Pesaro: the Death of Sᵗ Peter Martyr. The picture which now accupies the place under the same name, is a late copy and, according to the judgement of all who have seen the original, quite unable to give an idea of the real value of Titian's work. Nowhere else had Titian so closely approached Michelangelo in the monumental grandeur of a few passionately agitated figures. (Michelangelo sojourned at that very time for a few months in Venice, as a fugitive.) Nor has Titian succeeded anywhere else in characterizing the surrounding landscape so completely as the witness of an affecting occurrance. I should like to refer the reader to the remarks written by Jacob Burckhardt in his Cicerone with reference to, and under the spell of, the original. Another splendid picture of the same period of Titian's activity (completed in 1533), that has not come down to us without injury, is the altarpiece of *Giovanni Elemosinario* in the church dedicated to him. We have to invoke the help of our fancy to imagine the spatial effect of the picture with its originally semi-circular top, which has unfortunately been cut off at a later date. The keen devotion expressed in the few figures of the Saint, the angel and the beggar, is truly touching. At the same time nowhere, perhaps, does the beauty of the harmony of blue, red and white, in which Titian used to delight, appear more clearly. From the same period dates an Annunciation of the Virgin, on the saircase of the *Scuola di San Rocco*, and the splendid picture of Tobias and the Angel at *San Marciliano*. Titian strikes a very different note in the large painting of the Presentation of the Virgin, which is now re-placed in the same position at the *Academy*, for which it was originally intended, when this room still belonged to the Scuola della Carità (in the years 1534—1538) (fig. 115). Here we find once more a resurrection of the old narrative art of Gentile Bellini and of Carpaccio in all the splendour of Titian's colour. In the midst of Venetian buildings — the wall of one of the houses immediately recalls the lozenge-shaped pattern on the Doges' Palace — a large crowd of people has collected, amongst them some senators, in order to watch the child Mary, as she ascends the broad steps of the staircase leading to the temple, full of reverend seriousness and yet a little droll withal. On the top of the staircase she is received by a benevolent, old high priest who is holding out his arms to her, accompanied by his adjuncts. The whole proceeding is depicted with the whole of Carpaccio's amiable

... sense of beauty of a great idealist. — At ... ly represented at his best. In 1523 he

Titian. Madonna of the Casa Pesaro. S. Maria dei Frari.

...e staircase which leads from
... disappoints the beholder by
... the heavy, clumsy forms of
... the *sala delle quattro porte*
...oned pictures. The beautiful
...ression and attitude, and the
...ce. Titian who had the habit
...picture unfinished to his pupils.
...age have a different character
...joy of life has departed from
...us conception: instead of the

... Virgin. Academy.

...ony of tones; instead of the
...kind of representation. But the
...ne more prominent, than before.
...erified. For old age dispenses
... the zenith of his life. Character
...h recalls the days of youth.
...his own, almost inexhaustible
...pictures to be that of a vigorous
...whirling enthusiasm of his As-
...ther picture of his early days,
...f life and at death. If Titian
...h superficial imitation, but the
...nding the essential difference

The Martyrdom of St Laurence at the *Gesuiti* in Venice is praised, and rightly so, as the most important work of this last period. It is true, the picture, which in itself is already sombre, has darkened and been painted over and is insufficiently lighted, so that full daylight (about midday) is needed for judging its merits. But then will be revealed the greatness of expression in the features of St Laurence, suffering and yet certain of victory. He reconciles us to the horrible demeanour of the wildly agitated, naked myrmidons, just as the mild light of the star twinkling above does to the uncanny, smoky glow of the furnace-fire and of the torch. — The large picture of the Descent of the Holy Ghost, which is preserved at the *Salute* church, is disappointing after the mighty impression of the altarpiece of St Laurence. The general movement appears here superficially only, not expressed as the outcome of the same inner necessity, though we can quite imagine, that such a picture painted in a broad liquid manner, must have particularly impressed the next generation of artists. In the sacristy of the same church are a few boldly foreshortened ceiling-pictures (Cain slaying Abel, David and Goliath, Sacrifice of Isaac). At *S. Salvatore* are two magnificent pictures of the Transfiguration and the Annunciation, both filled whith grand life, the latter the most beautiful realization of this subject among the different versions painted by Titian in the course of his life. The *Academy* also has two of the most valuable pictures of Titian's late period: St John the Baptist, a seriously handsome, severe looking preacher in the wilderness, who with powerful gesture is addressing the people — and his last picture: the *Pietà* (fig. 116). How many times may not the old man of nearly a hundred years of age have sat before this canvas, until the deadly plague took the brush from his hand! A pupil, Palma Giovine, has completed, what the master was not allowed to complete. But from behind his brushmarks, from behind the touching-up and dirt of centuries, shines once more the genius, admiration of whose works has often left us speechless. The idea of this composition is grand. Under the shimmering gold of a domed niche Mary is seated erect like a princess with an expression of sublime grief, holding in her arms the body of her Son. On the right kneels Joseph of Arimathia, seizing full of humble love the hand of the dead Master; from the left Magdalen rushes forward, wild despair in her aspect. Thus in the three living the same feeling is touchingly expressed in three different variations. We would willingly credit Palma with the accessories, the little angel with the chrismatory, and the stone effigies of Moses and of Christian Faith.

It is one of the peculiarities of the works of great masters, that they bear the character of necessity, like the works of nature. In looking at them we feel, that everything must be thus and in no way different. This applies in full measure to Titian, but not to the majority of the Venetian painters of his time,

...ng into competition with the ...*ovanni Antonio da Pordenone* ...ng man to Venice, where he ...Giorgione, Palma and Titian. ...o intimate relations with either ...colour, which came near to

...ademy.

...healthy beauty which looked ...special merit was a powerful ...painted. Yet he was not the ...ony, true originality and even ...less and senseless movement ...of the late renaissance, because ...e composition is tedious. This ...to his large chief work of the

Patriarch Giustiniani with four other Saints, at the *Academy*, although we do not wish to deny the solid qualities of drawing, colouring and effective light (fig. 117). The Academy also has from his brush the large Madonna of the Carmelites and a few less important paintings; *San Rocco* the boldly foreshortenet single figures of SS. Martin and Christopher; and *S. Maria degli Angeli* at *Murano* a feeble, late picture of the Annunciation. His altarpiece of St Roch with SS. Catherine and Sebastian at *S. Giovanni Elemosinario* again did not come up to Titian's beautiful and simple painting of the saintly patron of the church, in spite of all Pordenone's efforts and to his fierce anger. The pictures which Pordenone had executed for the hall of the Great Council, have perished in the fateful fire of 1577, and all that remains of his Venetian frescoes is some faint traces in the cloister of *San Stefano*.

Sebastiano del Piombo was more tasteful and more happily gifted, than Pordenone; on the other hand he was even more lacking in that high necessity of artistic expression. This is best proved by the great change of front with he made. The only eclectic among the Venetians of his time, he betrayed in his maturity the colouring of Giorgione to the mighty style of Michelangelo's forms. The works which he has created in his thus improved manner in Rome, are certainly most important in some cases, but never entirely pleasing. After all, he never came nearer the great Michelangelo, than any clever epigone might have done, whilst he lost more and more of the freshness of his Venetian colouring. We much prefer to dwell upon the great picture of his early days, which still remains in Venice: the altarpiece of St John Chrysostomus in the church didicated to this Saint (fig. 118). Dignified and serious the pious old man sits at his desk, absorbed in his writing, and oblivious of all that passes around him, when from the left approach three of the most beautiful, dark-eyed Venetian women, disguised as SS. Catherine, Magdalen and Agnes, whilst a curly youth in the garb of St John the Baptist meets them with languishing eyes. Thus a kind of naive sensuality is mingled quite naturally with the devoutness of the religious picture. And this is thoroughly Venetian. The warm colouring, the fulness of the drapery and the type of the men's faces betray the school of Giorgione. We may well ask, what would have become of Giorgione, had he remained in Venice after such a promising beginning.

From about the same time dates the splendid picture of the Pietà at the Academy, which is ascribed to *Rocco Marconi*, owing to anologies with his signed pictures at *S. Giovanni e Paolo* (Christ between SS. Andrew and Paul) and at the *Royal Palace* (Christ and the Adulteress) (fig. 119). The clearness of the atmosphere above the carefully painted landscape and a certain embarrass-ment in the expression of the beautiful faces in the foremost group show the master to have been one who still stood on the soil of the quattrocento. The

...h he may demean himself as ... *Academy*, which describes the ...k to the Doge, is still entirely ...th Gentile Bellini or Carpaccio, ...to show the beholder as much

... ounded by Saints. Academy.

...ture is rather fine and carefully ... one questions oneself, whether ... who considered it "the best- ...Ve miss in it naive freshness, ...20). Wherever Bordone tries to ... masters of Venice in pictorial ... y so. Vide the Last Supper at

at the *Academy* or the restless, agitated
He felt most at home, when he had to
his task with honest simplicity and with
ctimes succeeded in producing imposing
best of our knowledge, none are to be

u Chrysostomus. S. Giovanni Crisostomo.

... in Venice, that is apt to alter
... pressed, is so grandly conceived,
... mposition to another master, to

... à. Academy.

... k had to suffer from the circum-
... yle of some few leading masters,
... ents of such a style. In Venice,
... attitude towards nature, talents
... aluable results in their own way,
... wers were insufficient for church
... quite contented, if they depicted
... scenes from every-day life, and

landscapes. Such was the task chosen by the groups of artists which were formed by the families of the *Bonifazi* and the *Bassani*. They have achieved the importance of pioneers, for they were the first genre painters and landscape painters of Italy. It is true, they had in Venice a whole succession of artistic ancestors, upon whose work they could base their own. In no other school of Italy had as much care been devoted to the landscape background, as here, and nowhere else had the artists of the quattrocento given as much loving attention to their daily surroundings, as Gentile Bellini and Carpaccio had done in Venice. However, the religious import of their representations had always been the chief concern of these worthy quattrocentists. This conviction we feel far more rarely with the Bonifazi, and hardly ever with Jacopo Bassano and his sons. With them the religious meaning is no longer the subject of, but only a pretext for their art. Surely the wealthy nobles of Venice rejoiced in seeing themselves so faithfully and pleasingly depicted by Bonifazio, or in finding again in Bassano's pictures their country-seats on the continent, the juicy meadows enlivened by shepherds, the farmhouses in the shade of old trees, and all the places where they loved to spend the hot months of the Summer. The preference of the townsman for country-life, which is tinged with a trace of sentimentality, became general at that time in Italy and found its reflection in art in the pictures of the Bassani. From the great number of pictures by these artists, which have come down to us, we may draw our conclusions as to their pupularity. The Venetians have certainly always lauded a Giorgione in higher terms, but the Bonifazi and Bassani were indemnified by that wide popularity which is always, the greatest reward for mediocre talents that know how to meet the taste of the public. In sacred and profane interiors, which elsewhere in Italy would have been decorated with frescoes, the long canvases of these painters were hung by side in long rows. Like many an one of the great Venetian artists, the Bonifazi and the Bassani were not children of the city of Venice. The first *Bonifazio*, who was not rivalled by any of his successors, was of Veronese origin, as is indicated already by his surname. After a life of probably fifty years he died in Venice in 1540. He reveals himself unmistakably as a pupil of Palma, from whom he derives the calm beauty of his women and the warmth of his colour. A delightful golden green, which was frequently used by Bonifazio, seems to have been a general secret of colour shared by all the Venetian painters of that period. In his method of painting Bonifazio employs a soft *sfumato*, even to a higher degree than Palma. If the attitude of his figures and his grouping make us feel the absence of Palma's incomparable sense of beauty, he delights us on the other hand by many small traits which he naively introduces. In his intentions he sometimes seems to be near the Dutch genre-painters of the seventeenth century, but his expression had of

...ic atmosphere, in which he lived.
...able and famous is the parable
...s represented rather as a reveller
...hes Bonifazio admitted the help
... pursued the same aims with less
...long the pictures at the Academy:
...f Salomon, and Christ and the

... St Mark to the Doge. Academy.

Adulteress. Of *Bonifazio II.* alone the Academy has a rather important work
in his Madonna sitting with the Infant under a tree between SS. Joseph,
Jerome and Catharine. The third Bonifazio who was born in Venice — perhaps
as a son of one of his two elder namesakes — shows the art of the family
already degenerating into triteness. Of his ten panels with pairs of Saints, at
the *Academy*, the most pleasing is perhaps the one which shows in effective
contrast St Bernard in a heavy priest's cloak by the side of the slender figure
of St Sebastian (fig. 121).

Of the Venetian private collection that of *Lady Layard* owns a series of
twelve small pictures by the elder Bonifazio which demand attention, if only
for their subject, as documents for the history of civilisation. They depict the
rural occupations in a similar way to that of the old German calendar pictures
of the twelve months.

The *Da Ponte* family, called *Bassano* from their native place, has been
honoured with one of the largest rooms of the Venice Academy. Through
numerous works we can here get acquainted with all the three members of the
family: *Jacopo*, the father, who had emigrated from the little provincial town,
and his Venetian sons *Francesco* and *Leandro*. Jacopo, who had received his
first instruction in art in his native place from his father, formed his definite
style later in the workshop of the elder Bonifazio, from whom he learnt that
naive art of relating a story, in which he afterwards even surpassed his master,
and also the supple manner of pictorial delivery in brilliant colours. His real
domain was the landscape picture enlivened by cattle and shepherds. As
an animal painter he had no rival. Of course, we miss in him, to a surprising
degree, the natural lightness of the colouring and of the shadows, which is
peculiar to objects under an open sky, and which has been reinstated in its
right by our modern open-air painters. Bassano's blue sky is still darker than
Bonifazio's; his shadows have a blackish depth, from which the local colours —
especially a ruby-coloured red — shine forth intensely like jewels. With all
this Jacopo Bassano, and of his sons particularly Leandro, also maintain a
certain position as portrait painters. Their portraits impress one as being very
true to life, although they lack the noble conception of a Titian or a Tintoretto.

Whilst in every other part of Italy art was on a decline that could not be
checked, especially since Michelangelo's late period, it continued to flourish in
Venice with unabated splendour until the turn of the sixteenth century. Its
standard-bearer was not only the aged, but ever fresh Titian, but by his
side stood two other artists of the first order: *Tintoretto* and *Paolo Veronese.*
Both of these left even Titian behind and solved new problems in a manner
which had been unknown hitherto, thus leaving the impress of their personality
upon that late period of Venetian art. Certainly there were equally great

...y could not develop without ...ed predestined, because they ...superhuman power. His gigantic ...s there a circle of connoisseurs ...the remains of antiquity, would

...1. Bonifazio Veronese III.
...rnhard and St Sebastian.

...in strong foreshortening. Their ...w exceptions, that of oil-painting ...ng of smaller pictures in heavy ...e ceiling-pictures.

...*Robusti* who, on account of his ...name *Tintoretto* (1518—1592).

Above the door of his workshop he had written the motto: *Il disegno di Michelangelo, il colorito di Tiziano.* But in reality he was better, than this motto would lead one to believe. He was by no means merely a clever eclectic, but a splendid personality of polished style. He possessed to a high degree the most precious of artistic gifts — imagination, added to which he had acquired by patient study an unusual knowledge of the human body and such sureness in the rendering of effects of light, that one might believe him to have been able to make the sun shine or to conjure up thunder-clouds. That he added a fine sense of colour to these other qualities, almost goes without saying in the case of a Venetian. The sum total of these gifts resulted with Tintoretto in a facility of production which had hitherto been unheard-of in Venice. We willingly believe that he could show ten times more area of painted canvas, than Titian. But at the same time Tintoretto was full of the consciousness of being able to outshine Titian in a certain sense as regards the idealism of his art. He gave expression to the feeling of power and inten-sified life, which was one of the characteristics of his time. In this he may have felt akin to Michelangelo, whose drawing he professed to emulate. Such an endeavour may very easily lead to empty exaggeration, as is proved by all the direct followers of Michelangelo. But Tintoretto was saved from this by his healthy naturalism. The slender elegance alone in the proportions of his figures forbade exaggerated manifestations of power, instead of which Tintoretto pleases us by an elegant grace which does not clash with the vivacity of movements.

Of great interest, artistically and as regards the history of civilization, appears to us his realism in religious subjects. It is true, that an evangelically religious mind will always take offence at the fearless realism which deliberately introduces ordinary modern, nay course, traits into the representations of the Crucifixion or the Last Supper. One's opinion may, however, undergo a change, if one brings before one's mind the fact that the Church, which was shaken in its very foundations, shrank from no means of reestablishing the hold of religious ideas upon the consciousness of humanity, which had become entirely wordly. Next to bewildering splendour, it was particularly the coursest natural-ness, which had to serve to produce an impression. Tintoretto appears the more as one of the most distinguished artistic representatives of this so-called counter-reformation, as he followed the tendency of the period entirely voluntarily.

To this must be added, that with his art of light and colour he knows how to reconcile, where he has offended by gross naturalism. This can be established step by step in the *Scuola di San Rocco* which, with its sixty-two pictures by Tintoretto, has become a veritable temple of fame for his art. Sometimes, when the subject permitted a preponderance of landscape, the

...o knows by magic effects of
...th a flowing brooklet into a
...derness) (fig. 122). Tintoretto
...ny art·lovers wrongly consider
...e depicts his sitters not quite

122. Tintoretto. St Mary in the
...derness. Scuola di San Rocco.

... As it is impossible here to
...en the important ones among
...appeared to him particularly
...was still bathed in a reflection
...has (in the Sala dell' Assunta)
...in slaying Abel. Below these
...Miracle of St Mark who saves

Saint who comes flying which his head ...hoever likes; but this must not spoil the ...ted figure of the slave and in the splendid, ...nding the victim with expressions of ... From the same period probably date ...el of the choir of *Santa Maria dell' Orto*, ...omb. The pictures, which describe with

he Doge Alvise Mocenigo. Academy.

...the golden Calf and the Last Judgement, ..., especially among artists. In the same ...conceived Martyrdom of St Agnes. Among ...*Place* (Old Library), the pictures of the ...belong to his erarly period. The small ...he *Salute* counts among its most treasured ...intoretto painted in 1561 and by way of ...s Last Supper at *S. Giorgio Maggiore* is

...the boldly individual conception
...g gnawing a bone in the fore-
...n objected to (fig. 125). From
...oretto was occupied with the
...these canvases, some of which
...ur attention, but others count
...al achievements. His Crucifixion
...narkable representations of this

St Mark. Academy.

...ly reckless realism all the minor
...making the description of the
...ivial light (fig. 126). Among the
...nately agitated rendering of the
...scape of St Mary in Egypt have
...he staircase the Visitation forms
...nnunciation. In the upper hall,
...leasing things, will be found an
...the year 1573. — Whilst he was
...d time to complete a number

share in the pictorial decoration of the
in all the rooms of state; to his dis-
cinity of Paolo Veronese who, with his
nt colours, generally gains the favour
Tintoretto's pictures are those in the
and Bacchus and Ariadne) and in the
the Doges kneeling before the Virgin
in the Hall of the Great Council, the
nd effort. Truly surprising is the art
s had never before been depicted, is

Supper. S. Giorgio Maggiore.

e, than by the lines of the composition.
omen's heads, are of supreme beauty:
il gives one nowhere time to breathe.
and shone in untarnished freshness of
e of the Venetian aristocracy. To-day,
much that has darkened or faded since.
Ring him in many respects, stood *Paolo*
gifts were not as varied as Tintoretto's,
posterity has given him more applause,
variably attained the complete harmony
ment — and therefore can be enjoyed

e in the spirit of Tintoretto, or
y Paolo Veronese, who preferred
e existence. In this he remained
ut he gave it a last and highest
in a thoroughly monumental

ifixion. Scuola di San Rocco.

erfect individuals, but an entire
the gay joy of life was with
ed themselves to the spectator
be gathered from the preceding
rial and without deeper intentions,
he costume. And superficial is
the painters who invite to deep

ugh we gratefully acknowledge the sum
his art has given to the world.
Veronese was far more careful than his
time, was not satisfied with the slick,
thus saved for posterity far more of the
y noteworthy is his art of composition.

St George and St Louis. Doges' Palace.

ow the famous example of Titian's Pala
a diagonally ascending line, instead of
hem he left — even in his broad pictures
oretto, and achieved by this means the
space. In this very respect the last of
much from him.
procured the twenty-seven years old
rona, his first important commission in
at *San Sebastiano*. They met with so

...rusted with the entire pictorial ...temple dedicated to the martyr ...use of Veronese, who banishes ...e it was, too, that the master ...en the world his best during

...o Ahasuerus. San Sebastiano.

...pictures, in which his assistants ...story of Queen Esther — most ...cession of the Queen descending ...period dates the ceiling picture ...gin. The finest of the altarpieces ...d by five other Saints. Tied to ...the body, his head towards a

on which is enthroned the Virgin with
angels and cherubs. By the side of it,
are the large pictures of the Martyrdom
cellinus on their way to the place of
osition in diagonal direction (fig. 129).
house of Simon, the Pharisee, which
of the adjoining convent, has later found
hurch of *Santa Caterina* guards as its
ystic marriage of its saintly patroness,

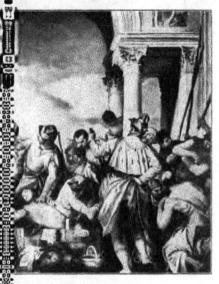

dom of S^t Sebastian. San Sebastiano.

the steps leading to the throne of the
heavenly bride, a tall, fair woman in a
the heavy cloak of gold brocade. No
d, how to combine into a harmony the
ant depth. Especially remarkable is the
s — as in this picture — to blue: another
Doges' Palace Veronese receives us in
his most lovable creations — the Rape
enough, has not much the appearance
ss seems only too pleased to mount the
re her. As regards the actual abduction

... comforted by the cupids that ...ture at the Doges' Palace has ... the ceiling of the same room ...pupils, is spoilt in the colouring. ... in the adjoining Hall of the ...the lower group of the kneeling

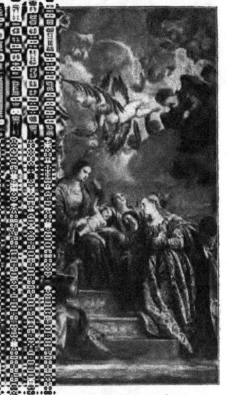

...o Veronese. Marriage of S^t Catharine. S^{ta} Catarina.

...nst the balustrade of a marble ...emy, the Battle of Lepanto is ...ed seapiece. The most beautiful ...ala dell' Assunta, who, holding ...he above a high marble socle, ...who supports the child S^t John

ly Families, which may be taken to be
are at *S. Francesco della Vigna* and at
the sum total of his artistic achieve-
neither the sacred, nor the legendary

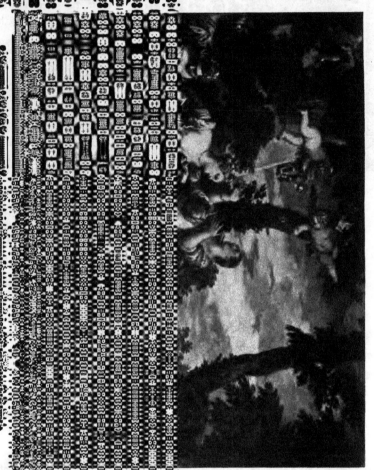

ich best corresponded to Paolo Veronese's
icture, if we may use this expression.
Never again has the banquet been depicted
ified a fashion, with such a mixture of
in the demeanour of all the persons taking
ously furnished board breathes sensual

which is the artist's avowed
expression of sensuality is so
...ur, that every trace of vulgarity
...ctures served for the adornment

...cture of the Battle of Lepanto".
...ollegio.

...any rate expect a different glori-
...hem have drifted abroad, but
...st, with splendid architectural
... in the house of Levi. Placed

... ent of S. Giovanni e Paolo, it now adorns ... al rooms at the *Academy* (fig. 134). ... great achievements were followed in

... ecadence. The generations of artists that ... universal interest, and if the historical ... during the eighteenth century, we could ... few remarks. But whilst in every other

part of Italy general exhaustion had set in in the domain of the fine arts, painting once more rose to short-lived splendour in Venice in the eighteenth century. In this sphere it was granted the Venetians again to celebrate triumphs, whilst in politics and in their national economy they could see nothing but degeneration, decline, and the forerunners of an approaching catastrophe. Nay, Venetian painting in the eighteenth century even brought forth a new achievement it had never before attained, by leaving us an almost complete picture of the town, of its inhabitants and culture.

Venice had always been one of the most picturesque cities of the world. What could have equalled in fantastic splendour the church of S^t Mark, the Doges' Palace, and their surroundings? — And again, was it possible to imagine more delightful street-views, than were offered at every step by the narrow network of canals and streets? — It is true, that the exterior of the lagoon-city had already at an earlier time inspired the imagination of her artistic sons. Gentile Bellini and Carpaccio have preserved for our benefit many a charming glimpse of old Venice; but they have only smuggled it, so to speak, into the backgrounds of their descriptive pictures, because according to the ideas of their time the portrayal of the town *per se* was not a task of art. This was only a discovery of the end of the seventeenth century. The first example was given by the paintings and etchings of *Luca Carlevaris*. However, the mere fact of having been the first constitutes his chief merit. His pictures, which have become very rare in Venice, are of little value. They lack the most precious quality of the true work of art, the soul of an artist's individuality. And this quality is just what we find in Carlevaris's successor and pupil, Antonio Canale (1697—1768). The elder Canaletto, as he has been called to distinguish him from his nephew with the same surname, has placed his whole life to the service of glorifying his native town. A number of pictures have come down to us, in which he depicts, apparently quite naively, all the well known views of Venice, which are to this day best liked by all travellers. Canaletto attached the greatest importance to every object and took care not to miss on any account a little window in one of his houses, so that everything could again be found in his picture, just as it was in reality. Nevertheless he painted with the soul of a Venetian, grouped his lights and shades in bold masses, to which end he made clever use of clouds, and reconciled all details with a warm, genuinely Venetian, golden tone of the atmosphere. It is truly lamentable, that Venice herself has kept hardly any of his works. The *Academy* possesses only one Canaletto (view of the Scuola di San Marco) and even this one is not beyond dispute. It is of course easy to understand, that foreigners of all people could appreciate these delightful views and carry them away as precious souvenirs of their visit. More than

that Canaletto and the other painters
foreign visitors and did not lose sight
aims. Whilst *Canaletto the younger,*

...ce, especially in Germany, with
...he direction of his uncle's art,
...ce. He, too, is only poorly
...t the *Museo Correr* and one at
...same views as Canaletto's. But
...overcome the childlike interest
...hich he treats with ease and
...of some personal mood. His

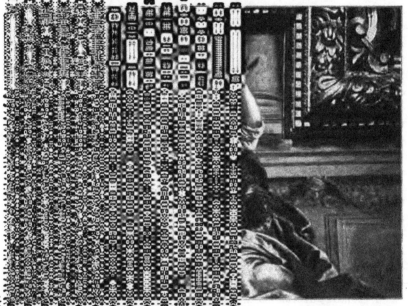

...of the Sala del Collegio. Doges' Palace.

...silvery tone of his landscapes
...ell, how much modern French
...ge of pigtails.
...each in his own way, but with
...*Longhi* describes the Venetians.
...masters of the early renaissance
...painters of views — Gentile Bellini
...riots before our eyes as clearly, as
...itian and Tintoretto, though they
...d the aristocracy of Venice in a

11*

number of worthy representatives. At Longhi's time the artists' style of representation had, of course, undergone a change, but even more so the character of their models. The Venetians, whom Longhi painted, were no longer the fresh, active men, the robust women of Carpaccio; nor were they the dignified nobili of Tintoretto; but they were a race of careless and effeminate idlers. Their outward bearing shows, that they know of no high aims, of no serious duties. Their days were spent in caring for their *toilette*, in gossip, in music and dance, in masquerades and love intrigues. Thus they were painted by Longhi, and thus they also appear in the chronicles of that period. Longhi as an artist was one of their number. He, too, lacked seriousness and high ambition. His personalities look so absent-minded, that they do not even devote full attention to their gallant occupations. One might therefore hesitate to mention Longhi's name at all in a list of great artists, if he were not so interesting a figure in the history of civilization. And furthermore it must be admitted, that he knew how to deliver his little anecdotes with the most amiable sense of humour. If you are overwhelmed by great art, you can take rest with Longhi. You will then learn to appreciate the fine sense of colour which had come to him as the heritage of a long succession of artistic ancestors. If you want to form a correct estimate of Longhi, you have to compare him with his contemporary Chodowiecki, who revealed a very similar talent in different surroundings. Longhi has also been compared with Hogarth, but, it seems to me, with less reason, for the Englishman was decidedly deeper, both as man and as artist. A number of Longhi's little pictures can be found at the *Academy* and at the *Museo Correr*. That he was induced to relate his *storiettes* also *al fresco* — on the staircase of the *Palazzo Grassi* — is somewhat comical, but everybody must admit, that he has solved his task in an original and excellent manner.

What there was of idealim in Venetian civilization at that period, is personified in *Giovanni Battista Tiepolo* (1696—1770). The nobles of the Republic were certainly corrupted to the very marrow of their bones, but they were still filled with the whole pride of their ancestors. They were still wealthy — through landed property and inheritance in conjunction with gradual diminuition of the families — and their superiority found expression in boastful extravagance. Never had the palaces been as large, the tombs of the Doges as pompous. Tiepolo's painting corresponded to this striving after monumental splendour. That he had hit upon the right thing for his time, is proved by the enthusiastic praise of his contemporaries and by the quantity and importance of his orders. In the Doges' Palace, it is true, hardly anything remained to be done. On the other hand the nobles of the city and of the *terra ferma* ordered large mural paintings for their palaces; further opportunities for such works were offered

...anded Tiepolo's works. He has ...e castle at Würzburg and died ...drid. Now, although the saying ..."his time, has lived for all time", ... generation to hold generally a

...ntra. Palazzo Labbia.

...time of their fathers. Goethe's ...known; it was shared by the ...ted by many even to-day. Faulty ...conjunction with daring handling, ...ainst Tiepolo since Goethe's days. ...oaches, but the fault lay not so

much in Tiepolo, as in the unreasonable demands made upon him. To realize
his artistic intentions Tiepolo was fully furnished with talent and with artistic
culture. He may well have been guilty of faulty drawing, may have represented
his men and women more as types, than as individuals, and yet achieve his
object of brilliant effect of space. Nay, as decorator Tiepolo signifies a final,
highest advance.

There are two opposite ways, in which mural painting can solve its problems
in a classic manner — either by explaining and accompanying in severe style
the architectural articulation, or by breaking boldly through the architecture
and treating wall or ceiling as open space, in which some occurrance takes
place, which it describes realistically.

The artist who embarks in this latter direction, must acknowledge in
Tiepolo one of his greatest models. Nobody else has known how to master the
largest spaces and achieve such homogeneous effects with such ease, nay grace.
Only Paolo Veronese of all his precursors can be compared with him. We
have already pointed out, how Paolo achieved greater depth by the atmosphere
which he left over his groups. But in the use of this device he appears a
mere duffer by the side of Tiepolo. Tiepolo knows how to make us gaze
into endless depths of space by the art with which he distributes small groups
and single figures — with matchless taste — at wide intervals. They float about,
light, bathed in atmosphere. And how well Tiepolo knows how to paint this
atmosphere! In his ceiling pictures the sky is opened. It is a fact which has
often been observed, that a ceiling by Tiepolo makes the whole room appear
loftier and wider, than it actually is.

The objective side is on the whole intirely indifferent to him. We need
not lose time over the allegorical twaddle of the eighteenth century. It is
really quite immaterial, whether Tiepolo had to paint the Transportation of
the House of the Virgin to Loreto (at the *Scalzi*), or the Finding of the Cross
(at the *Academy*), or Pegasus unfettered (in the *Palazzo Labbia*). The way of
thinking of his time not only permitted, but demanded, that every subject —
religious, allegorical, or historical — if it was to be presented in monumental
style, had to be raised to the same Olympian height, and furnished with the
same finery of angels or cupids and flowing, silken robes. Even if the occurence
must needs take place on level ground, it was given that heroic magnificence.
Especially in such a case the impression upon our mind is entirely theatrical.
Observe the intentional *grandezza*, with which Antony and Cleopatra meet on
the frescoes of the Palazzo Labbia (fig. 136). Tiepolo was not a born painter
of easel pictures. He lacked completely the sense of deep observation, which
is required for this. But this is by no means to imply, that his smaller pictures
are without charm. Far from it! They have the same qualities as his large

... like much reduced ceiling or ...*demy:* the Vision of St Cajetan, ...ints.

...ame to an end. A generation ...public of St Mark collapsed. If ...l institutions, there would be no ...debris also buried a high culture ...f Venice. — When after the lapse ...rly conditions, when Venice was ...rich nobles had long ceased to ...ve ennobled the leisure of these ...h chiselling and painting is still ...nly the models are Venetian.

...zzo Sanudo-Vanaxel.

INDEX.

The Asterisks (*) refer to the illustrations.

FAMOUS ART CITIES

A SERIES OF ILLUSTRATED MONOGRAPHS
ON THE HISTORY OF THE GREAT ART
CENTRES OF THE WORLD;

EDITED BY

ARTUR SEEMANN

Richly illustrated and tastefully bound.
Royal 8vo Cloth, gilt top △▽△▽△▽△▽△

Vol. I. POMPEII by Prof. R. ENGELMANN, with 145 Illustrations, translated by TALFOURD ELY, M.A., F.S.A.

" II. VENICE by G. PAULI, with 137 Illustrations

In the Press

Vol. III. NÜREMBERG by P. J. REE, with 153 Illustrations

" IV. FLORENCE by A. PHILIPPI, with 200 Illustrations

to be followed by

SIENA, CAIRO, CONSTANTINOPLE, RAVENNA, ROME, PARIS, BRUGES, GHENT, SEVILLE, PISA, BOLOGNA, STRASSBURG, MOSCOW ETC.

THESE charming Volumes, as regards excellence of taste and wealth of Illustration, will compare favourably with the most expensive works which have been published on the same subjects.

Taken together they will form a complete History of the great Art Centres, but each volume may be purchased separately. Art students and amateurs will be sure to welcome these beautiful Monographs, as they will serve a double purpose. They will not only be a trustworthy Guide to the history and works of art of the cities to which they refer, but also a permanent reminder and a perpetual souvenir of the objects seen and admired.